HARPER & ROW, PUBLISHERS NEW YORK

CAMBRIDGE LONDON HAGERSTOWN MEXICO CITY

PHILADELPHIA SAO PAULO SAN FRANCISCO SYDNEY

NUDE
PHOTOGRAPHS
1850-1980

EDITED BY CONSTANCE SULLIVAN

HARPER & ROW, PUBLISHERS

FIRST EDITION

80 81 82 83 84 10 9 8 7 6 5 4 3 2 1

CONTENTS

FOREWORD

THIS book is the outcome of an elaborate search into the photographic past and represents a personal view rather than an attempt at systematic, critical definition. It articulates a curiosity about eroticism in photography since its beginnings. It is essentially a collection of pictures to be looked at and enjoyed.

The 134 photographs reproduced here were culled from thousands preserved in art museums, libraries, galleries, public and private collections throughout America and Europe. They were made over almost a century and a half by anonymous amateurs and professionals, as well as the foremost practitioners in the field. What they share in common is subject matter, integrity, and astonishing beauty.

A journey of discovery that began with notions about what would be found, yielded sometimes disconcerting, often joyful revelations. Certain preoccu-

pations and preferences asserted themselves during the process. The photographer's intention and purpose in the work was a principal interest. It varied from artistic or commercial to purely documentary, as in the portrait of a wounded Civil War veteran commissioned by the surgeon general of the United States (*Plate* 20) or the anatomical study done for the French army toward the end of the nineteenth century (*Plate* 16). Other intriguing questions were the relationship between the photographer and the person photographed; the attitude of that person toward being photographed nude; the depiction of personality; the elements of performance, gesture, touch. The presence of clothing seemed as significant as its absence. Interiors, dense with detail and information, held endless mystery. After all aspects of a photograph were considered, the deciding factor in choosing was pleasure.

CONSTANCE SULLIVAN

NUDE

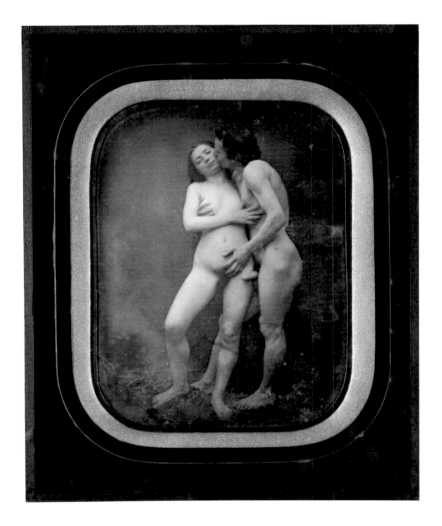

1. FR. J. MOULIN, *circa* 1855

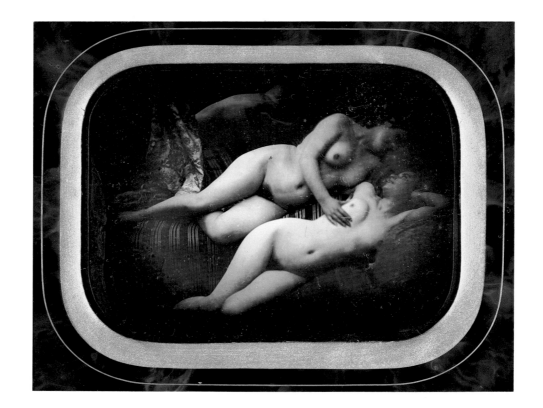

2. ANONYMOUS, *circa* 1850

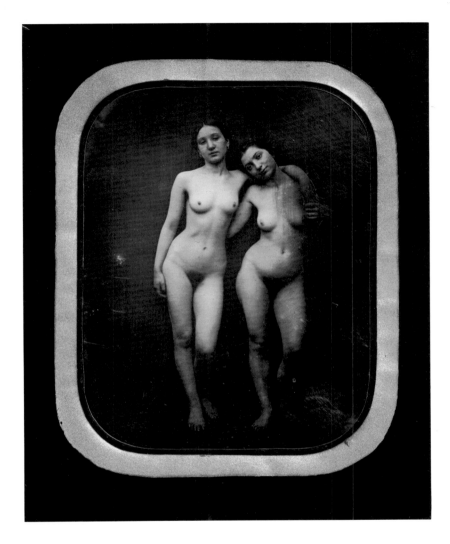

3. ANONYMOUS, *circa* 1855

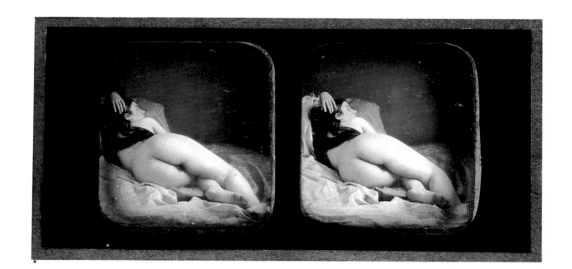

4. ANONYMOUS, *circa* 1855

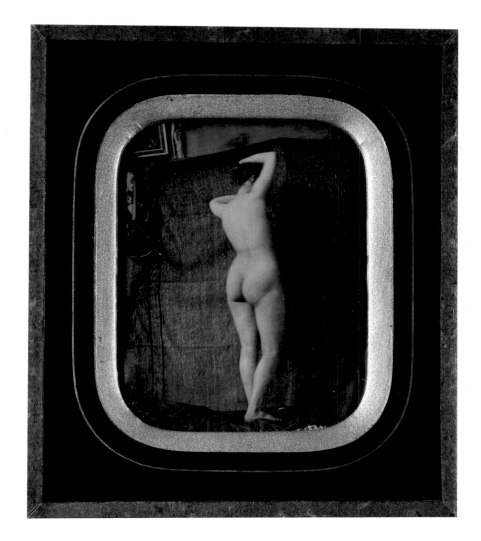

5. ANONYMOUS, *circa* 1850

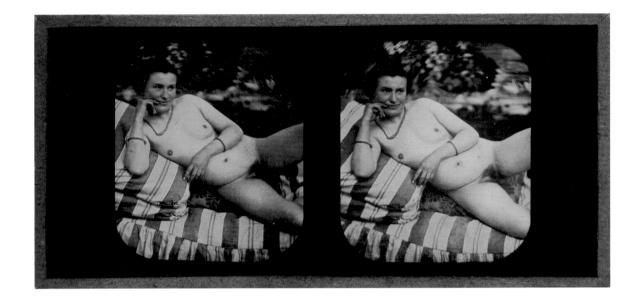

6. ANONYMOUS, *circa* 1855

7. ANONYMOUS, *circa* 1855

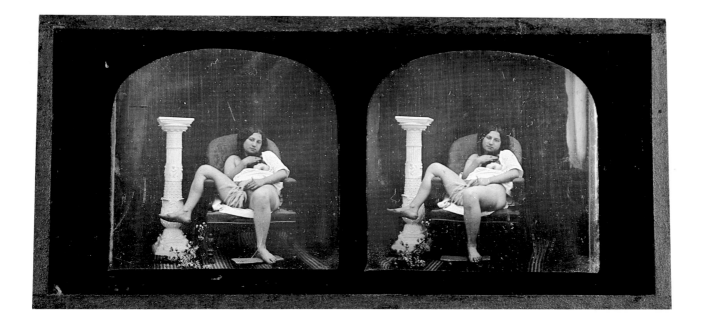

8. ANONYMOUS, *circa* 1855

9. ANONYMOUS, *circa* 1855

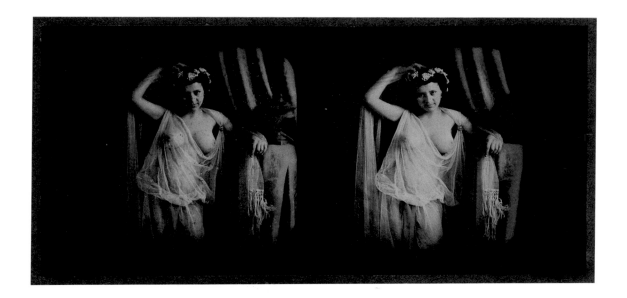

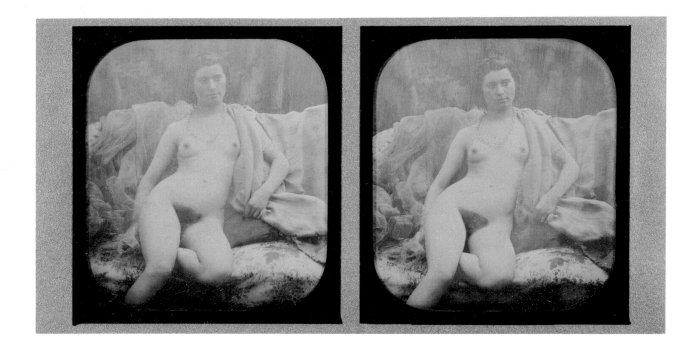

10. ANONYMOUS, *circa* 1850

11. ANONYMOUS, *circa* 1855

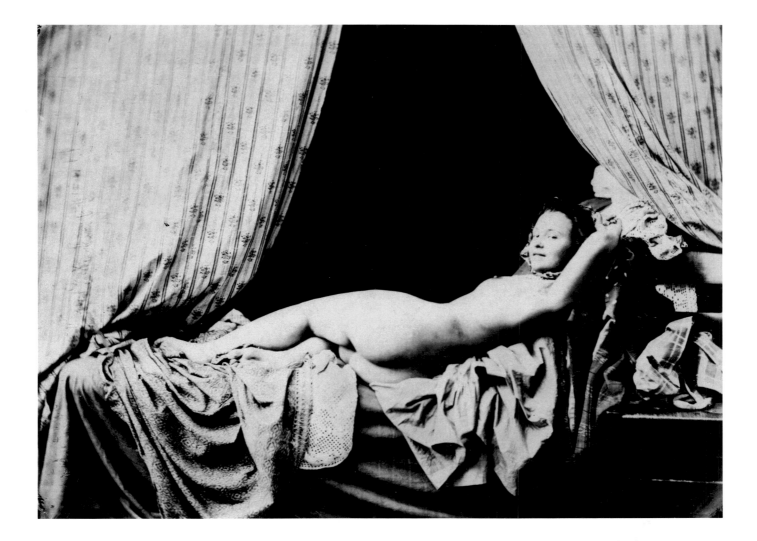

12. BRAQUEHAIS, *circa* 1856

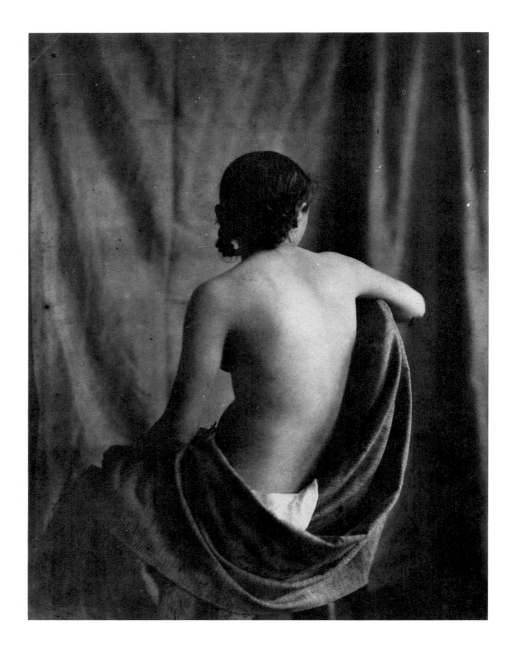

13. EUGÈNE DURIEU, *circa* 1853

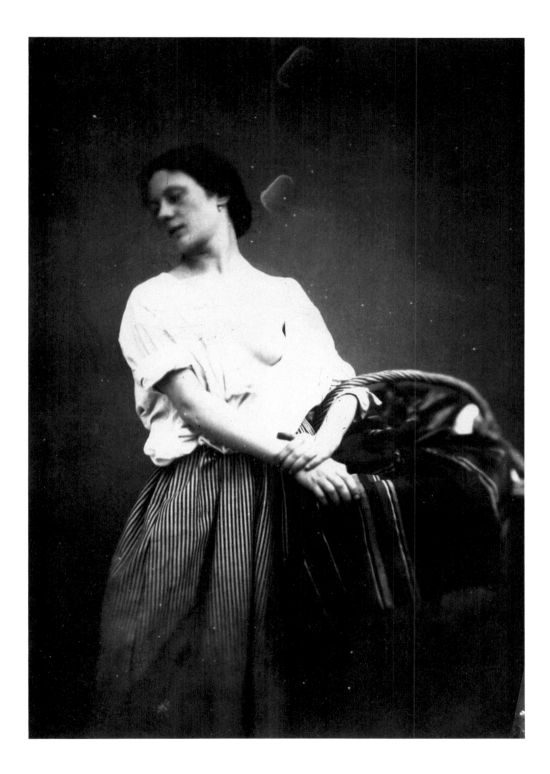

14. BRAQUEHAIS, *circa* 1854

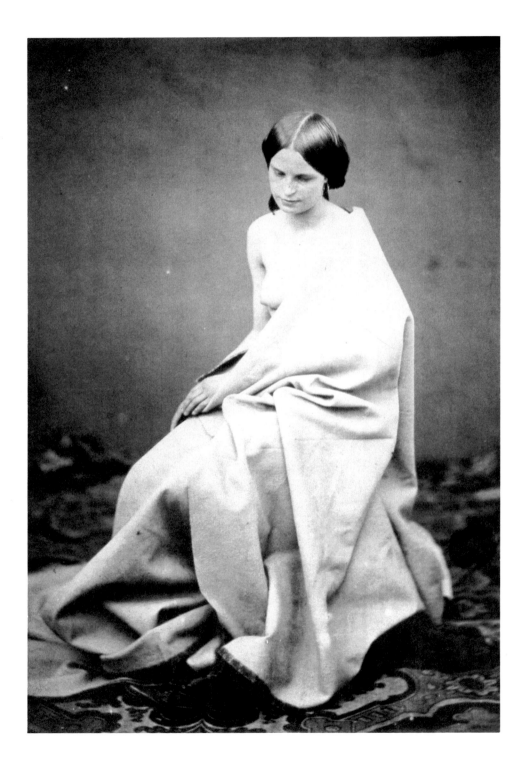

15. ROGER FENTON, *circa* 1855

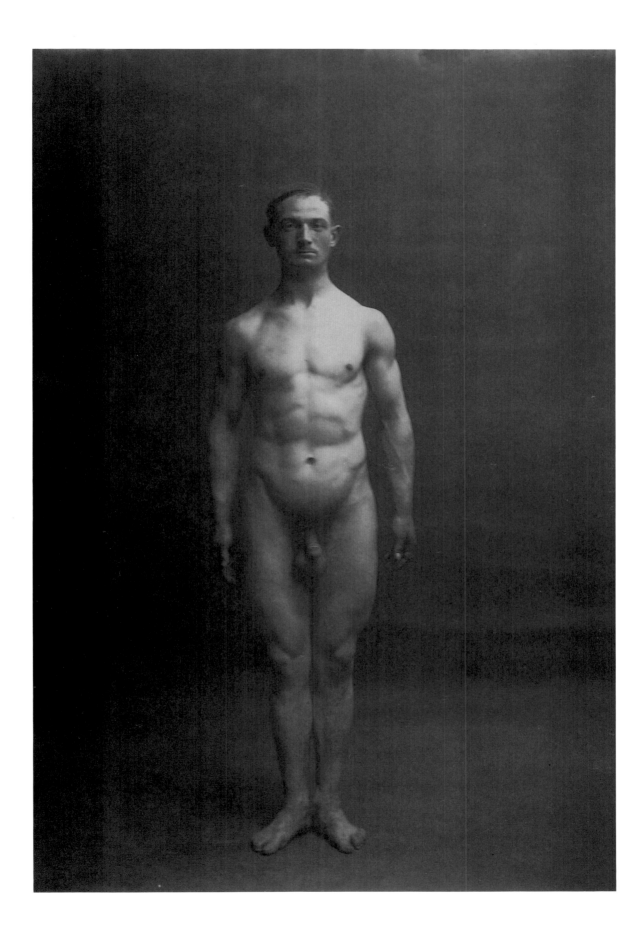

16. ANONYMOUS, *circa* 1880

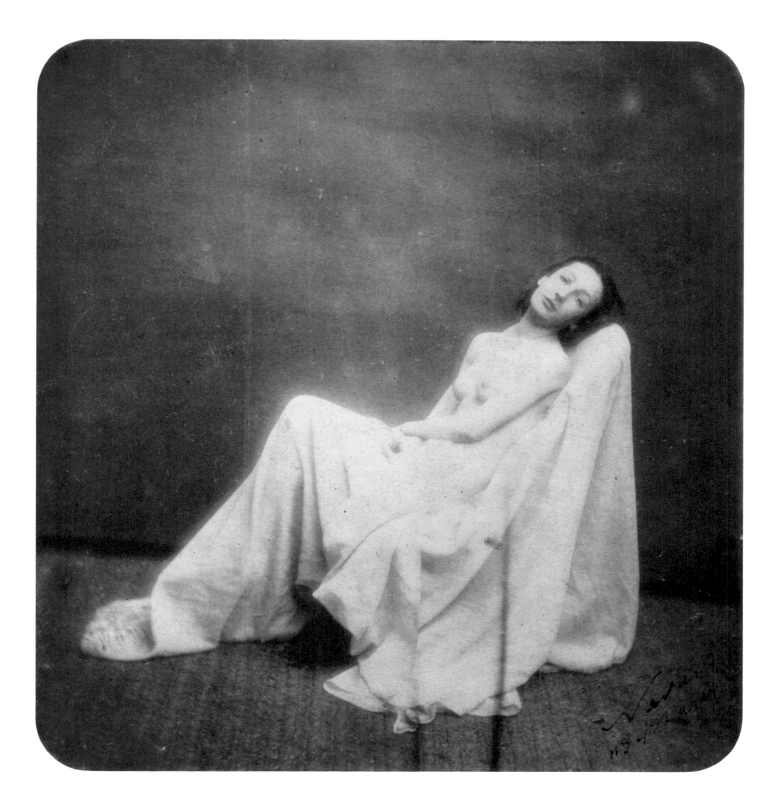

17. NADAR, *circa* 1860

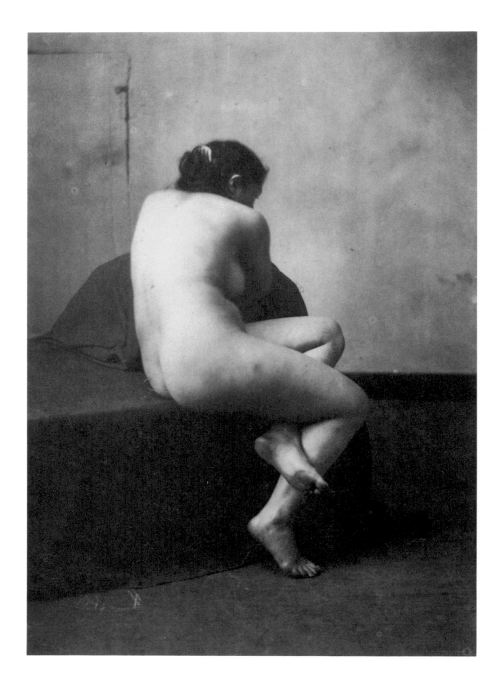

18. ANONYMOUS, *circa* 1855

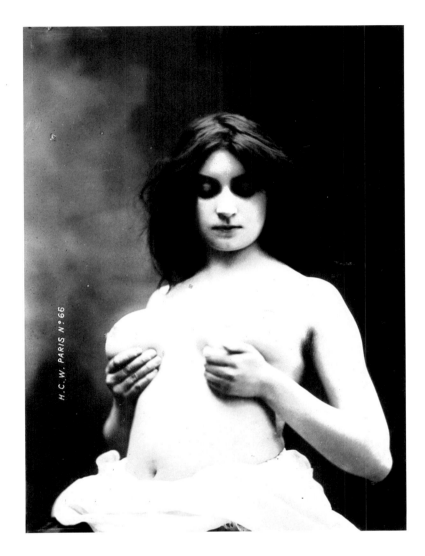

19. ANONYMOUS, *circa* 1900

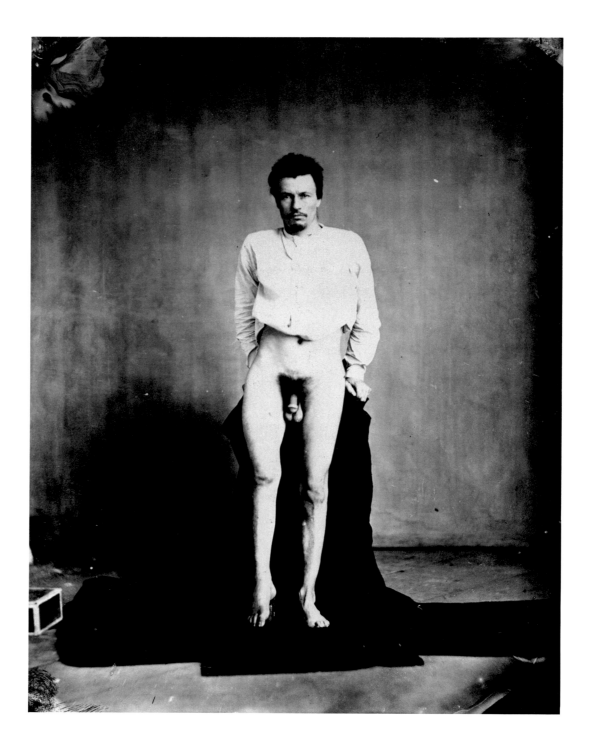

20. ANONYMOUS, *n.d.*

21. NADAR, *circa* 1860

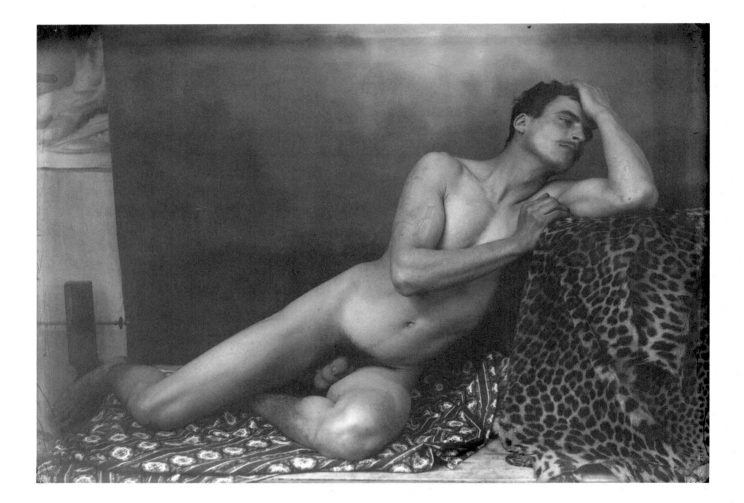

22. BARON WILHELM VON GLOEDEN, *circa* 1890

23. BARON WILHELM VON GLOEDEN, *circa* 1890

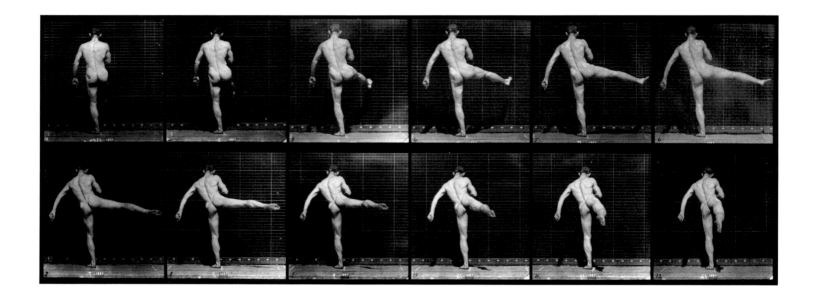

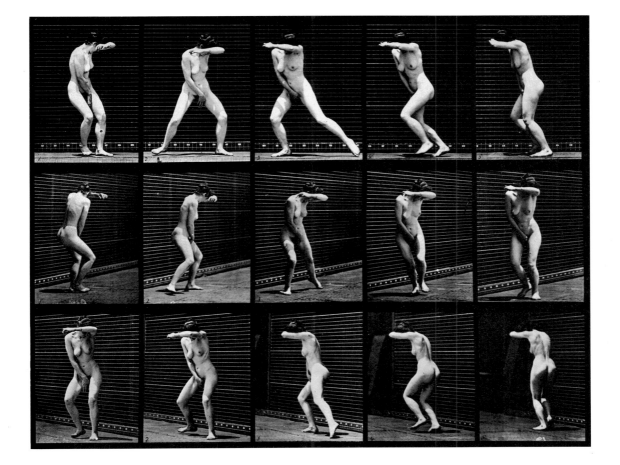

25. EADWEARD MUYBRIDGE, 1887

26. THOMAS EAKINS, *circa* 1883

27. THOMAS EAKINS, *circa* 1883

28. THOMAS EAKINS, *circa* 1883

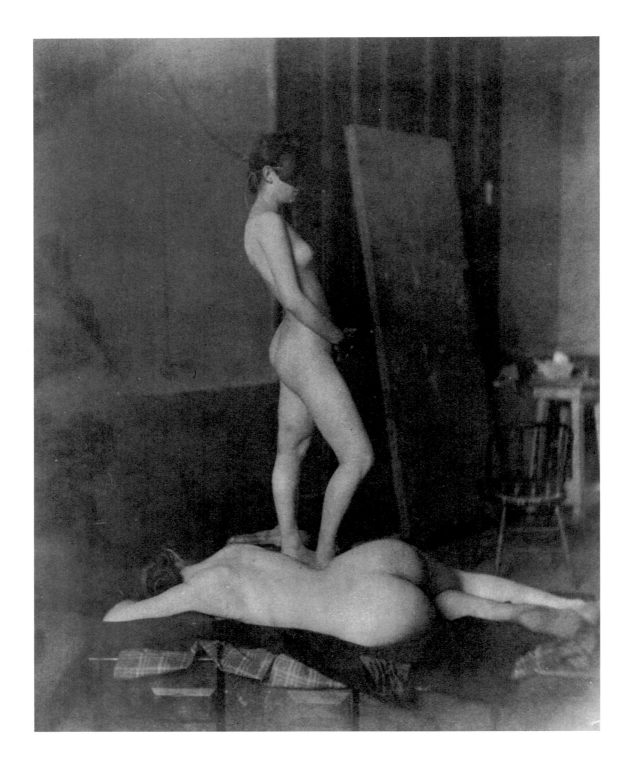

29. THOMAS EAKINS, *circa* 1883

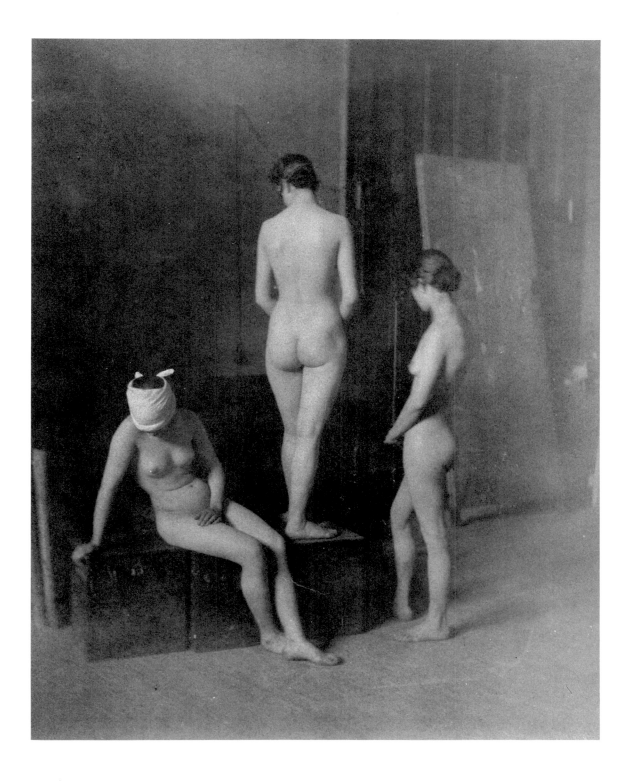

30. THOMAS EAKINS, *circa* 1883

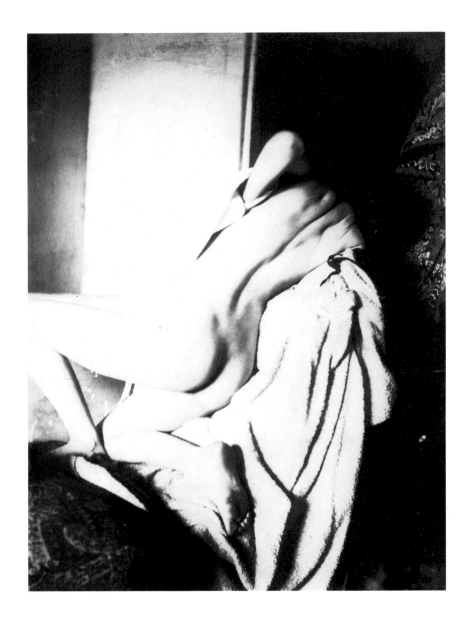

31. *Attributed to* EDGAR DEGAS, *circa* 1895

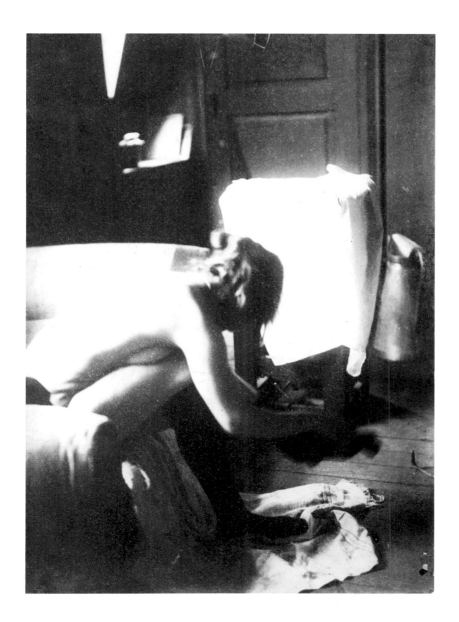

32. *Attributed to* EDGAR DEGAS, *circa* 1895

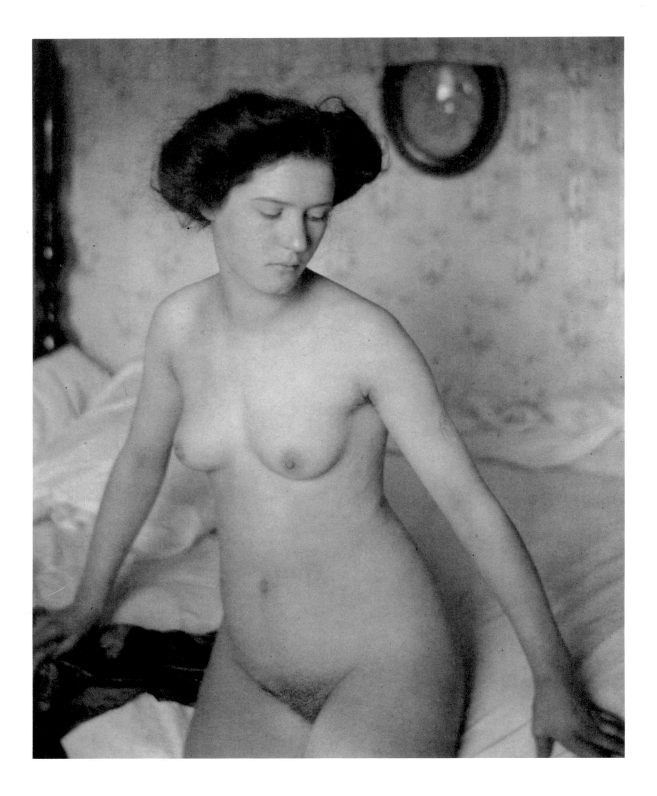

33. CLARENCE H. WHITE & ALFRED STIEGLITZ, 1907

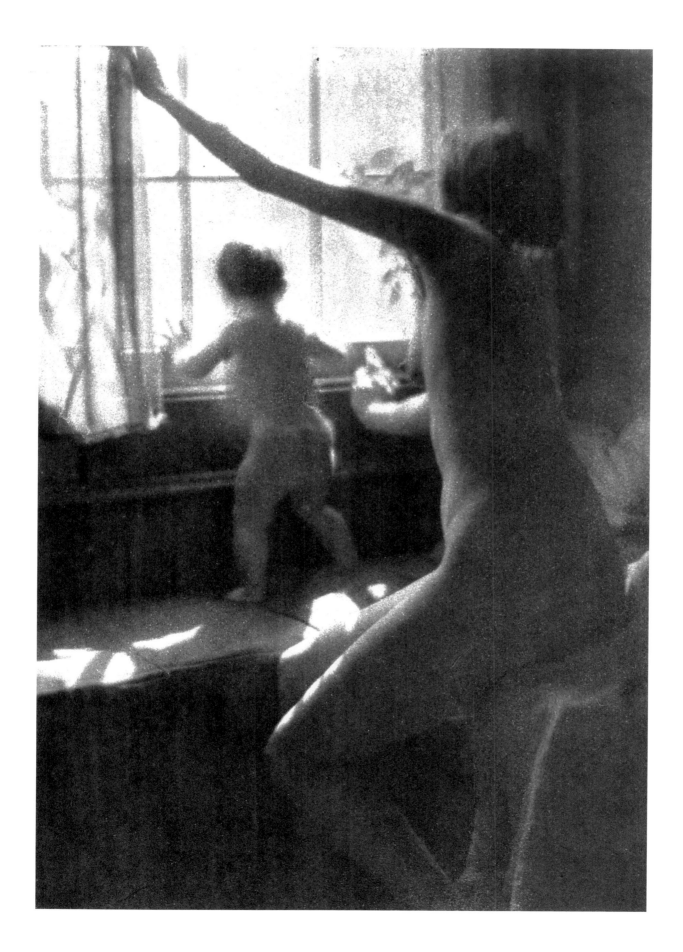

34. CLARENCE H. WHITE, 1912

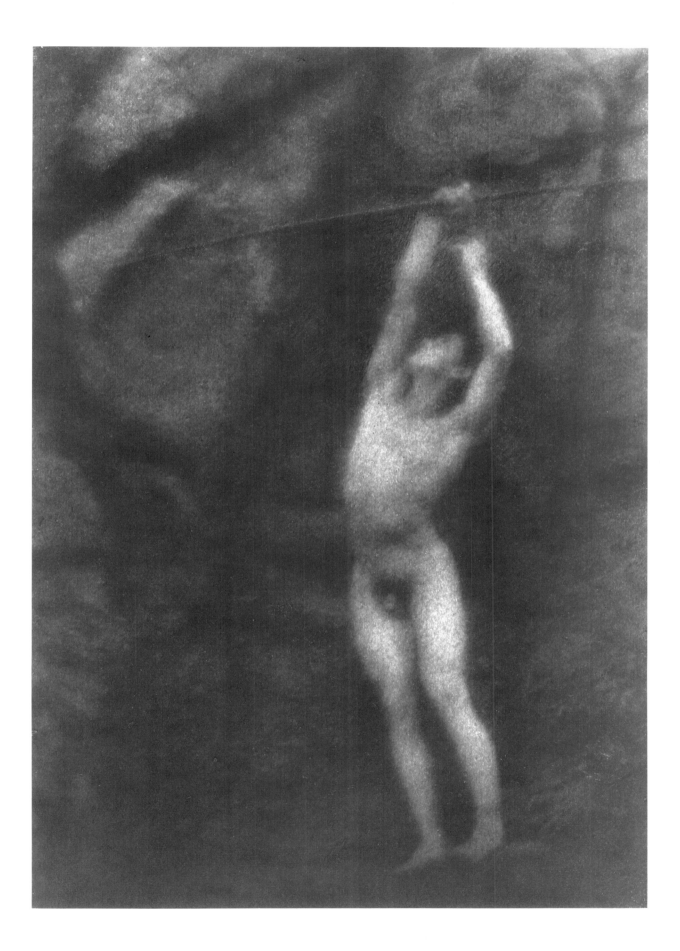

35. F. HOLLAND DAY, *n.d.*

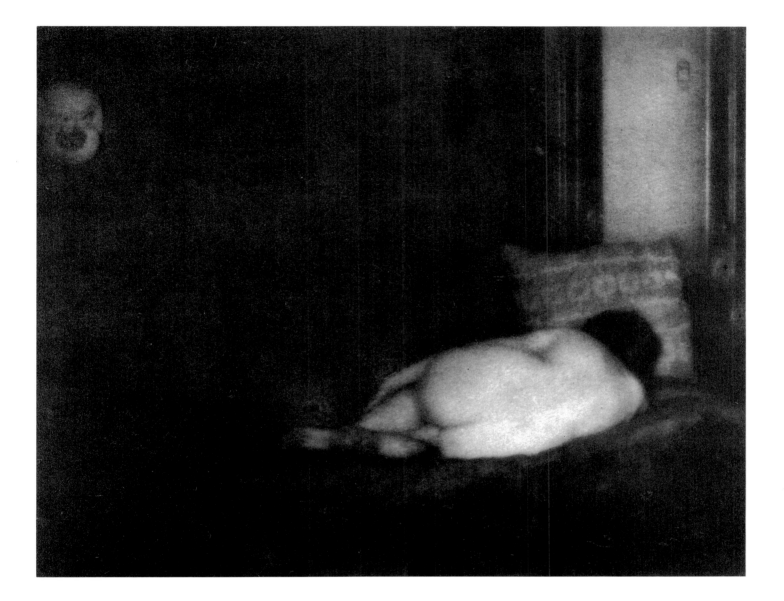

36. EDWARD STEICHEN, 1906

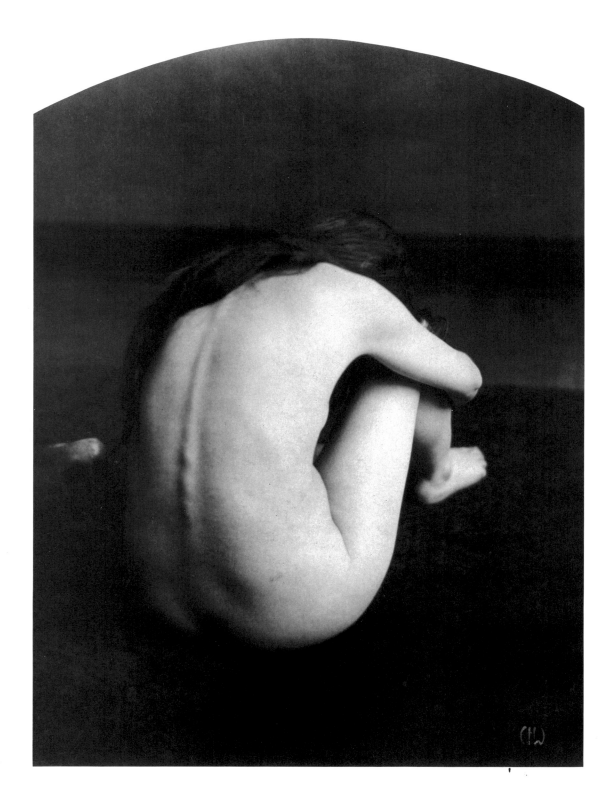

37. CLARENCE H. WHITE & ALFRED STIEGLITZ, *circa* 1900

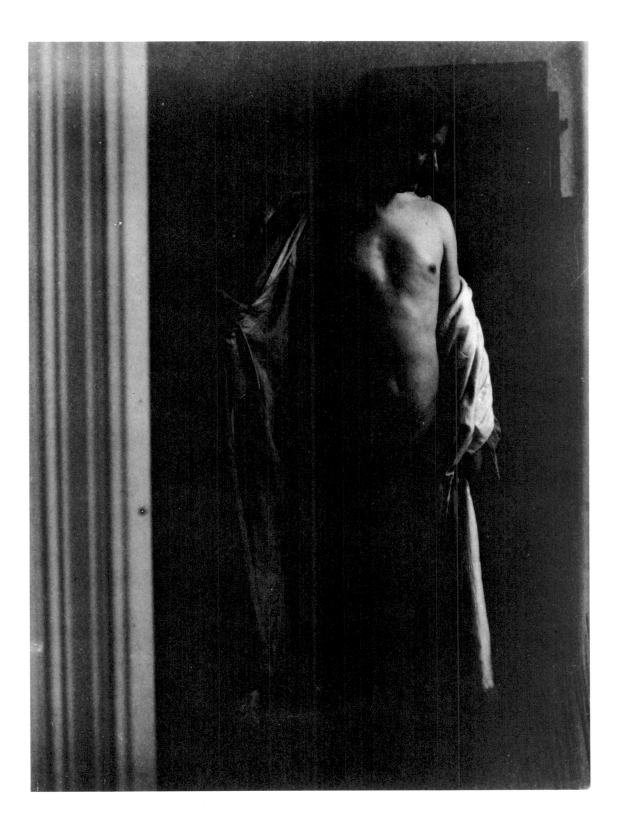

38. FRANK EUGENE, 1913

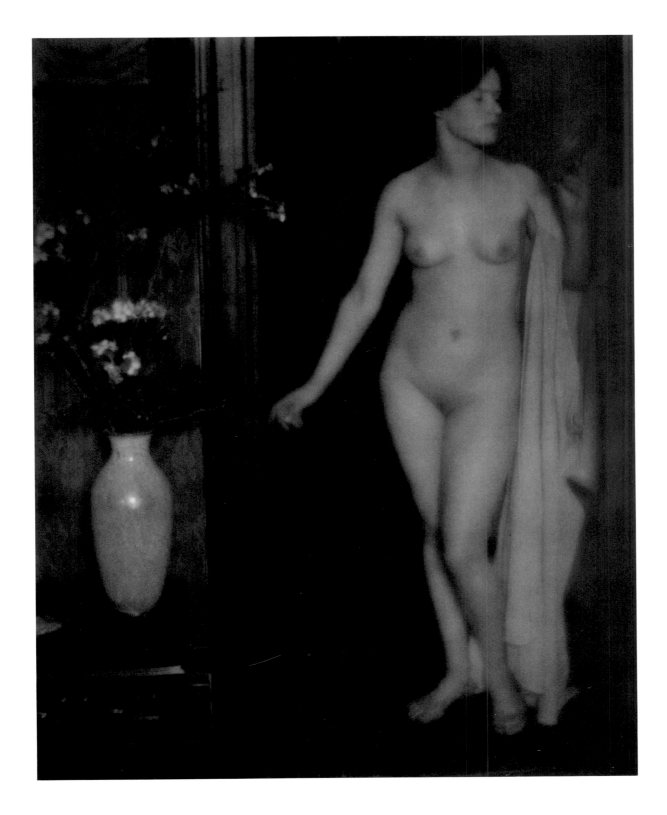

39. CLARENCE H. WHITE & ALFRED STIEGLITZ, 1907

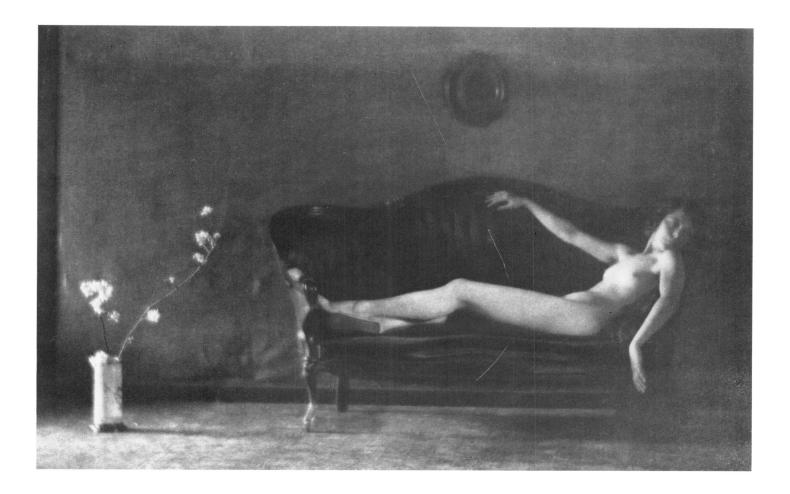

40. EDWARD WESTON, *circa* 1923

43. IMOGEN CUNNINGHAM, 1923

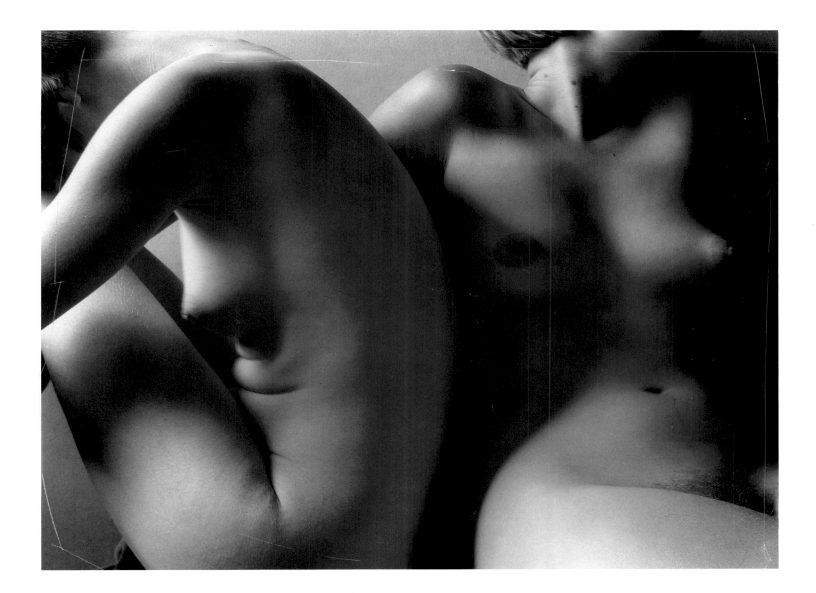

44. IMOGEN CUNNINGHAM, 1928

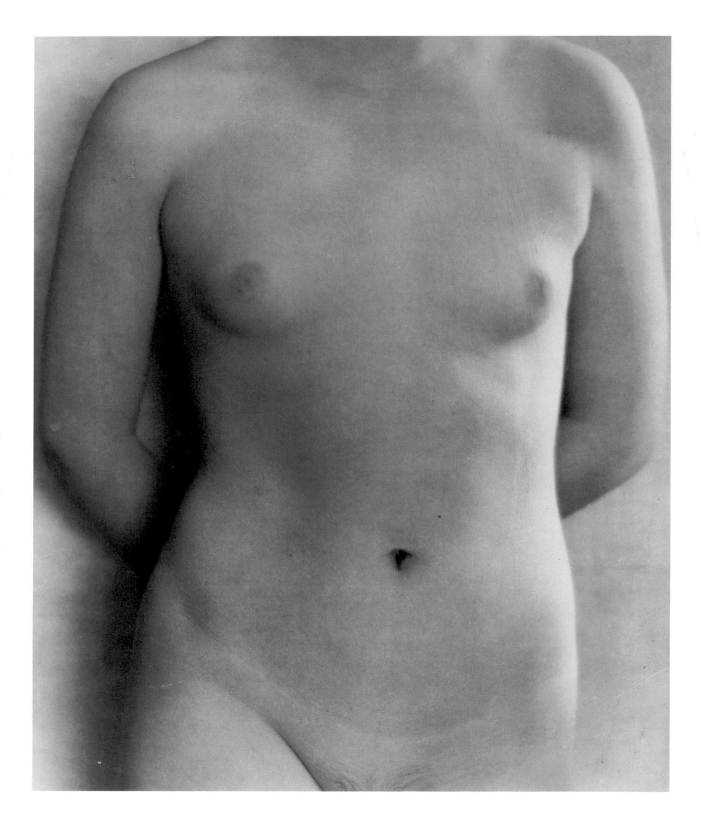

45. DOROTHEA LANGE, 1923

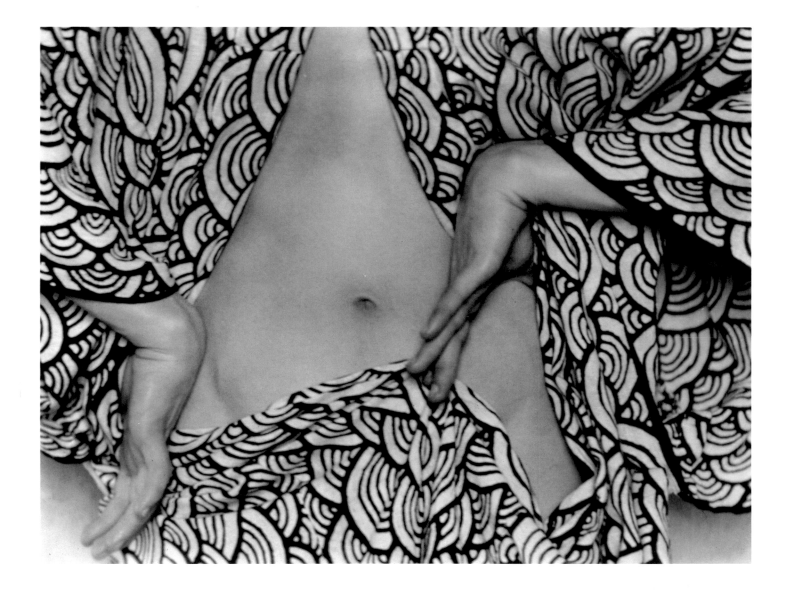

46. MARGRETHE MATHER, *circa* 1923

47. EDWARD WESTON, 1922

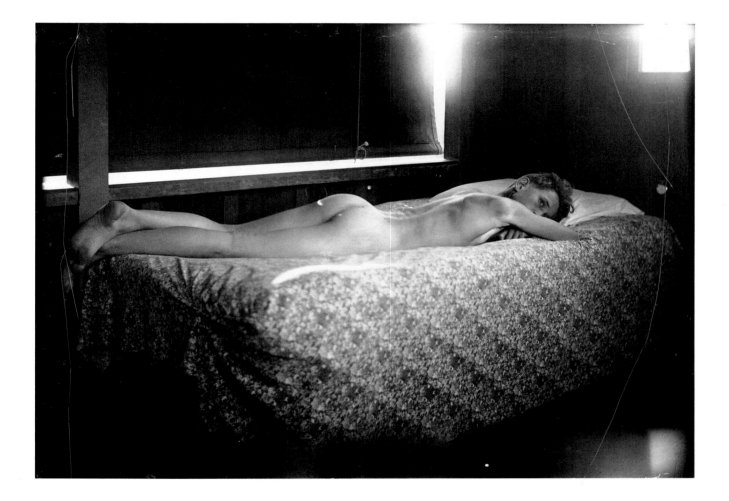

49. ANONYMOUS, *circa* 1910

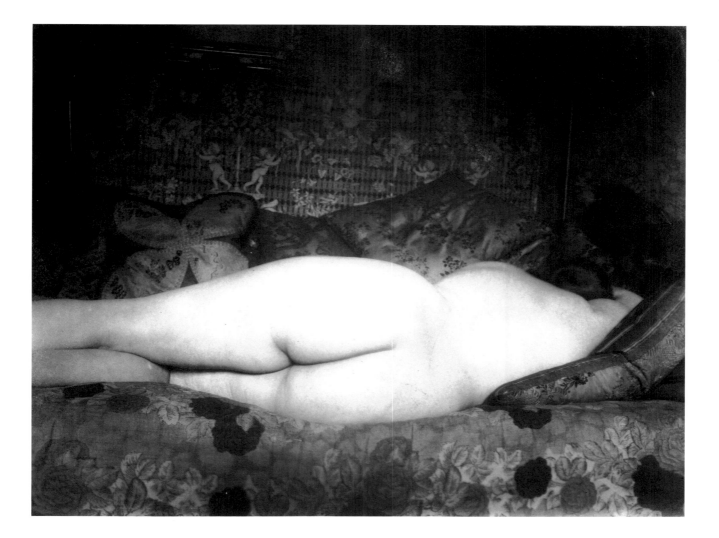

50. ATGET, *circa* 1910

51. E. J. BELLOCQ, *circa* 1912

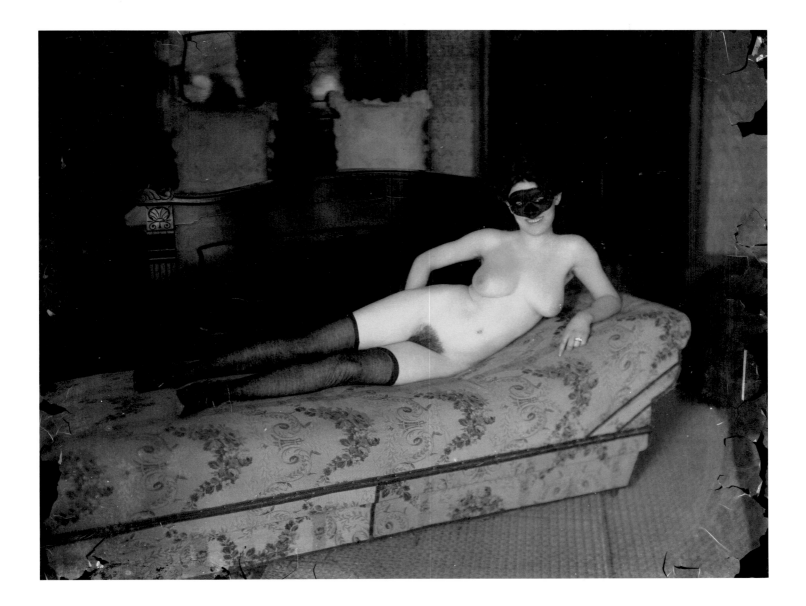

52. E. J. BELLOCQ, *circa* 1912

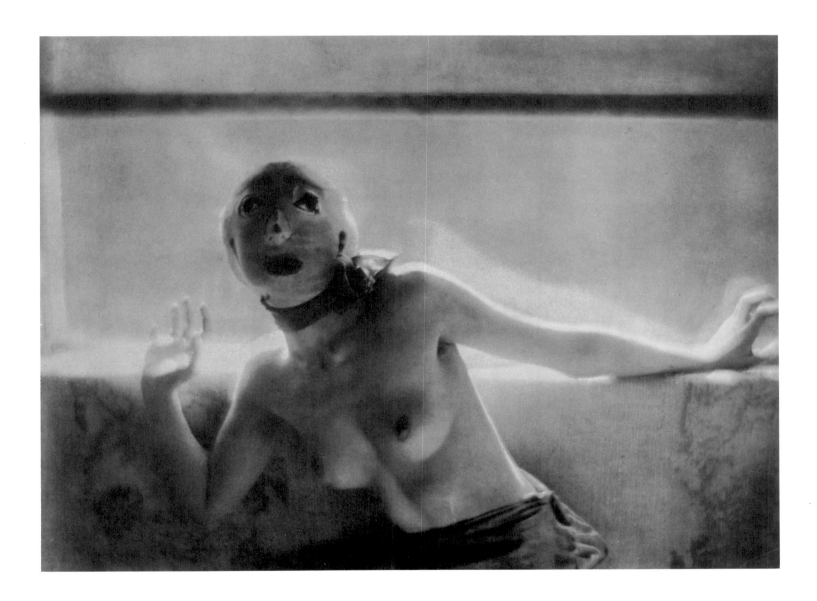

53. BARON ADOLPH DE MEYER, *circa* 1912

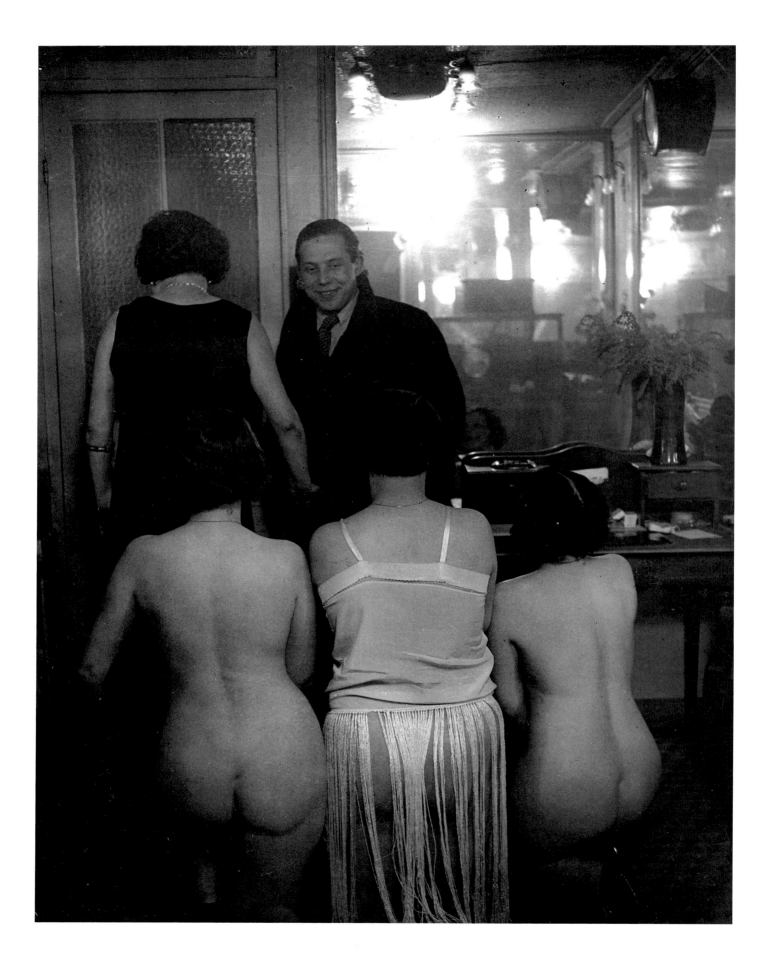

54. BRASSAÏ, *circa* 1932

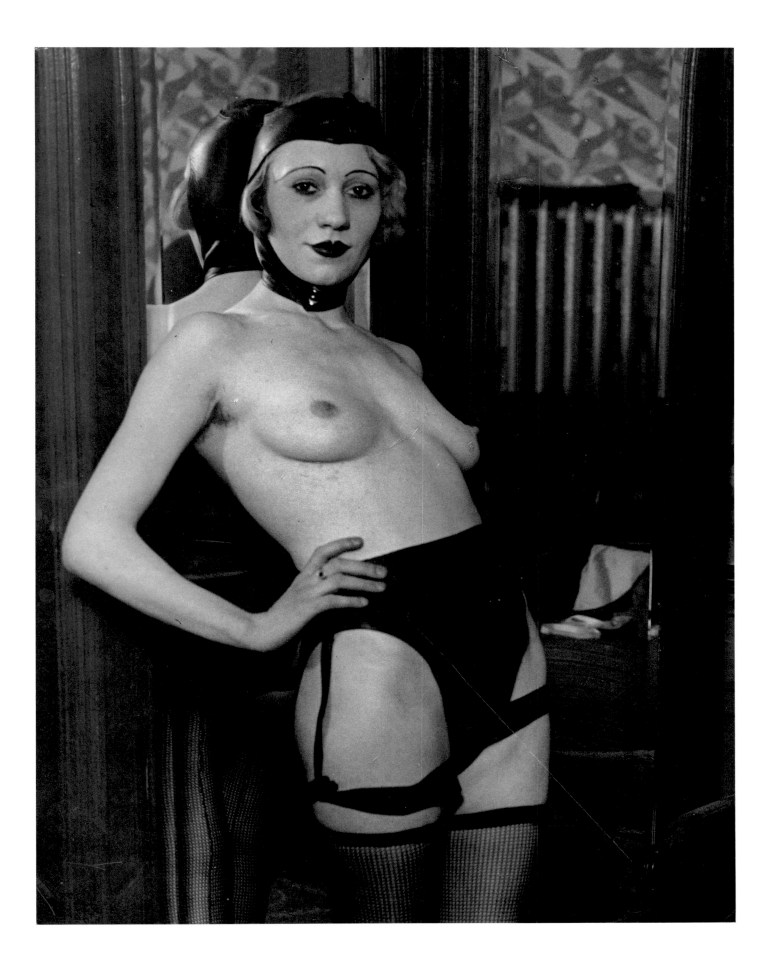

55. BRASSAÏ, *circa* 1932

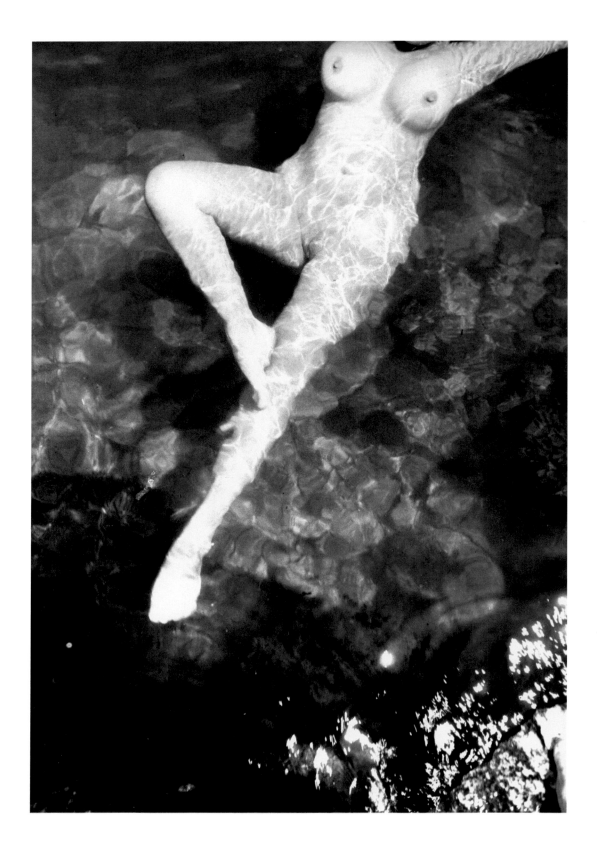

56. HENRI CARTIER-BRESSON, 1933

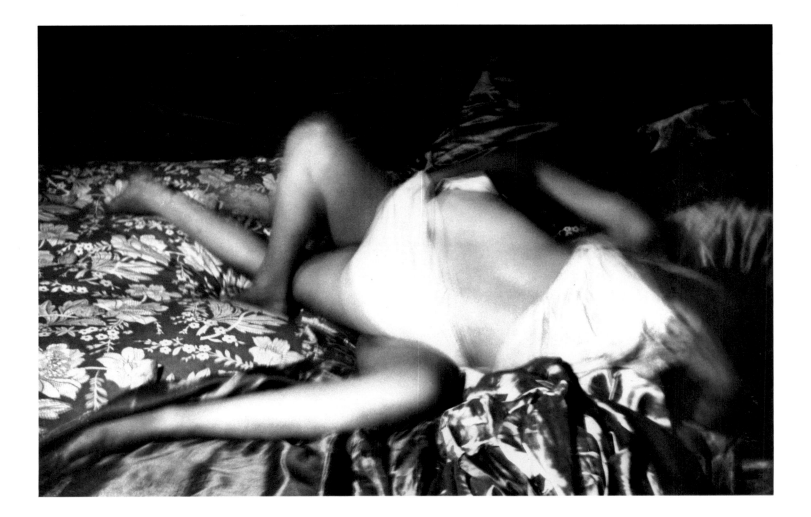

57. HENRI CARTIER-BRESSON, 1934

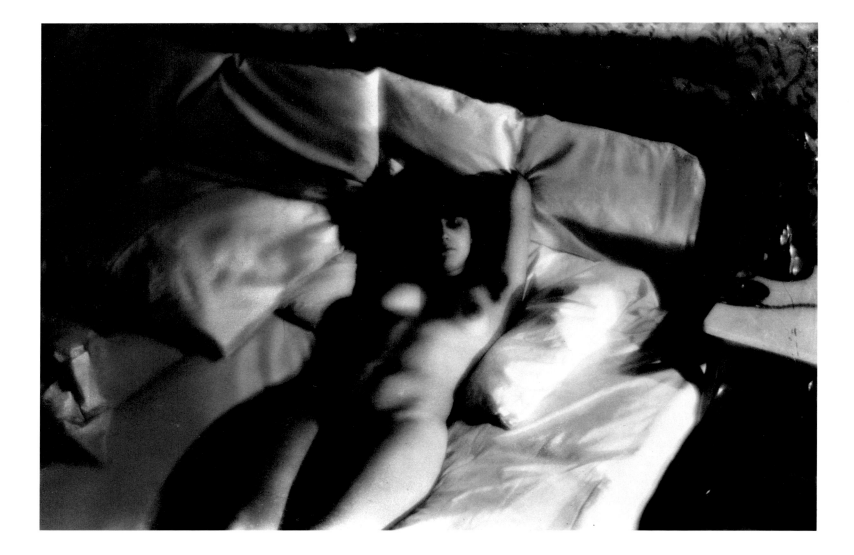

58. MARTIN MUNKACSI, *circa* 1929

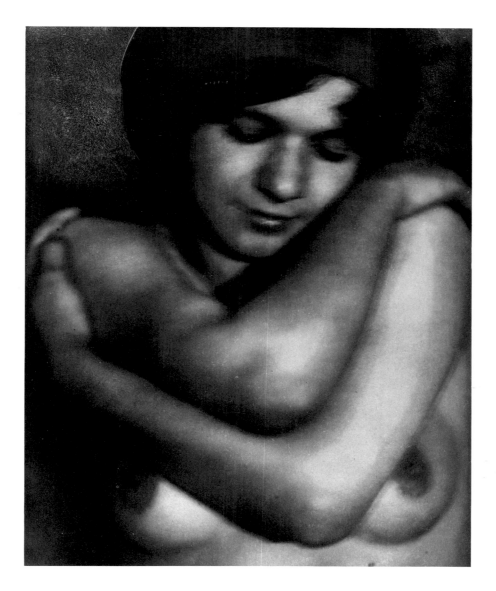

59. FRANTIŠEK DRTIKOL, 1929

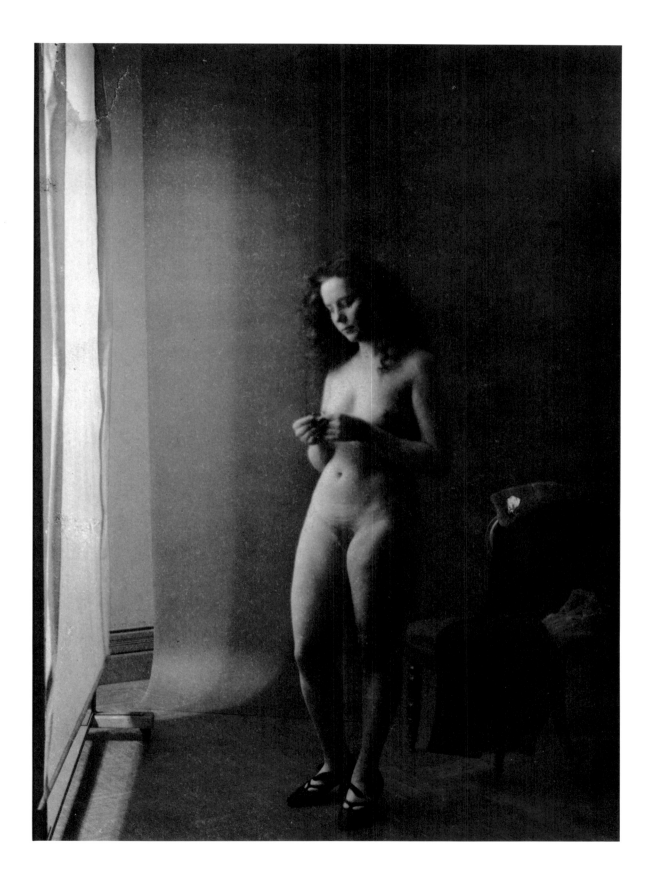

60. PAUL OUTERBRIDGE, JR., *circa* 1924

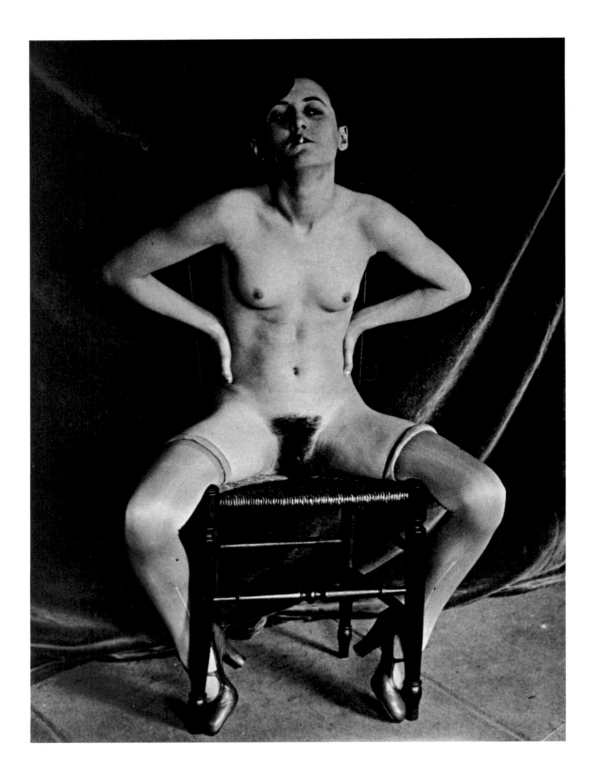

61. ANONYMOUS, *circa* 1895

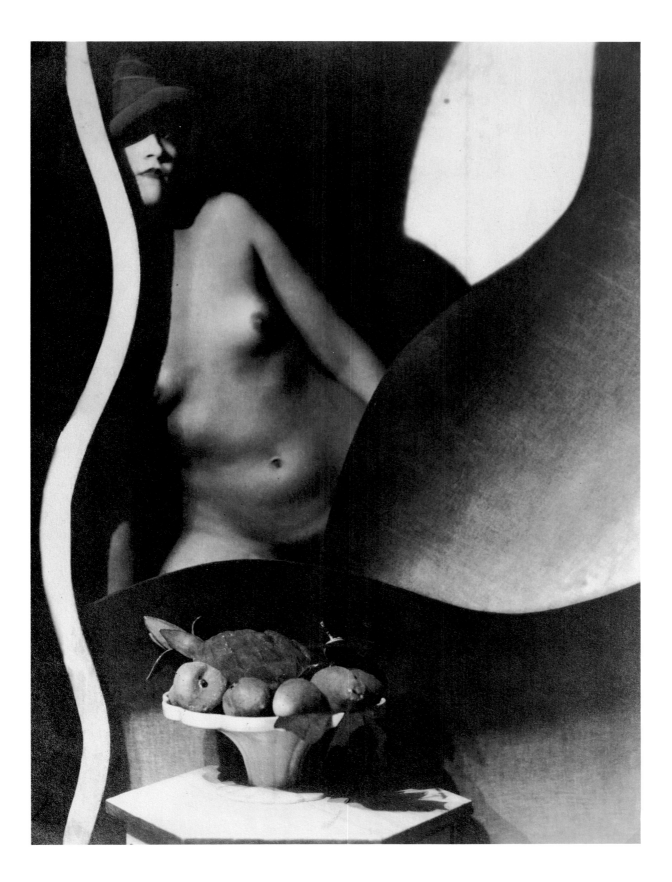

62. FRANTIŠEK DRTIKOL, *n.d.*

63. PAUL OUTERBRIDGE, JR., *circa* 1928

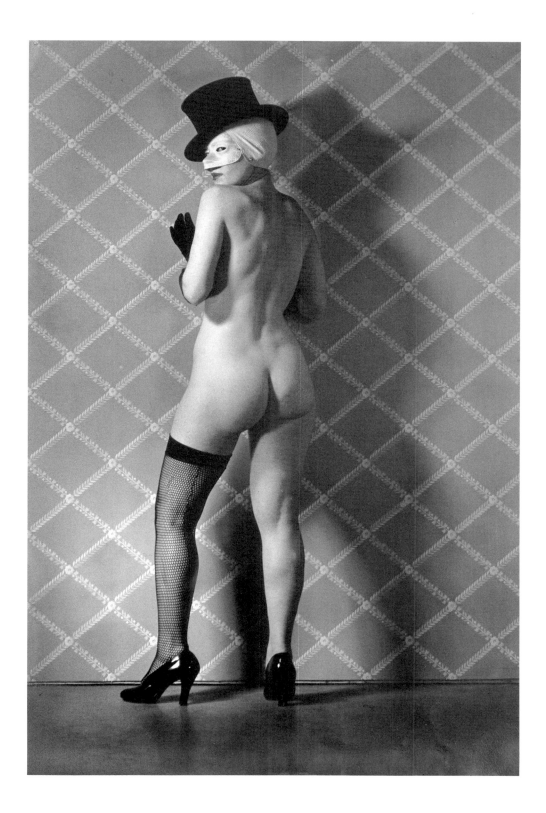

64. PAUL OUTERBRIDGE, JR., 1938

65. HANS BELLMER, *n.d.*

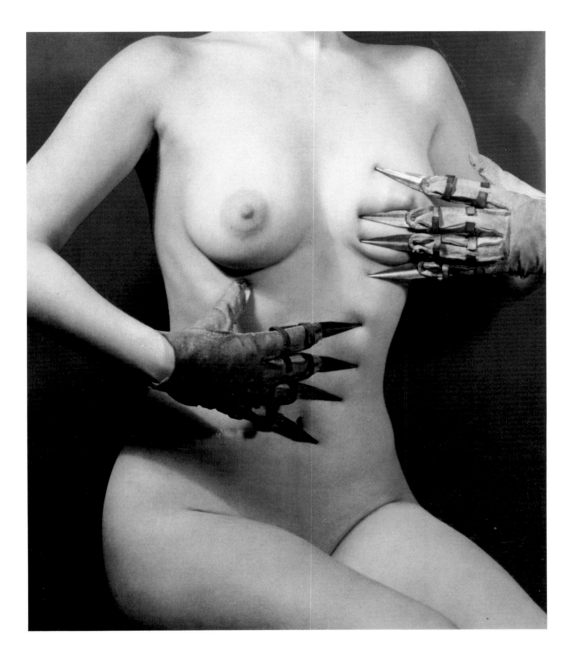

66. PAUL OUTERBRIDGE, JR., *n.d.*

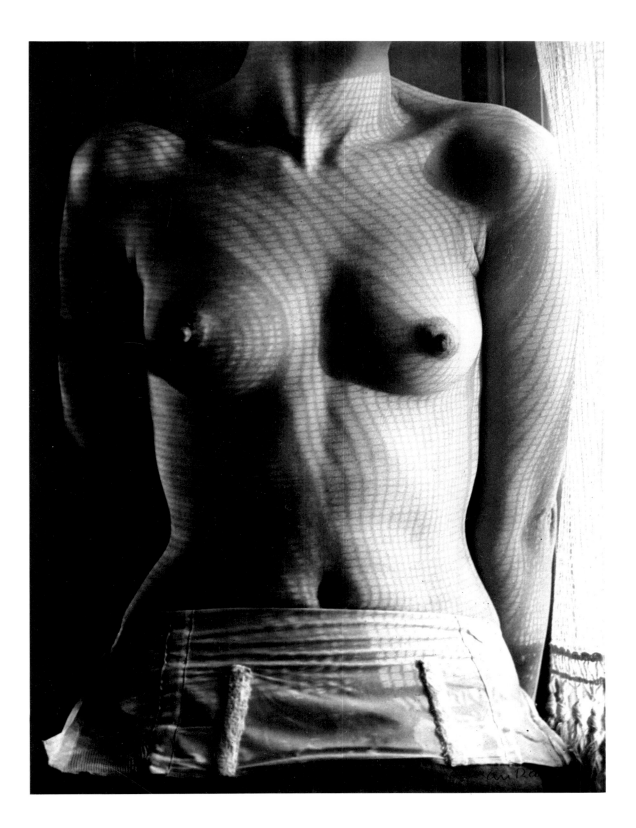

67. MAN RAY, *n.d.*

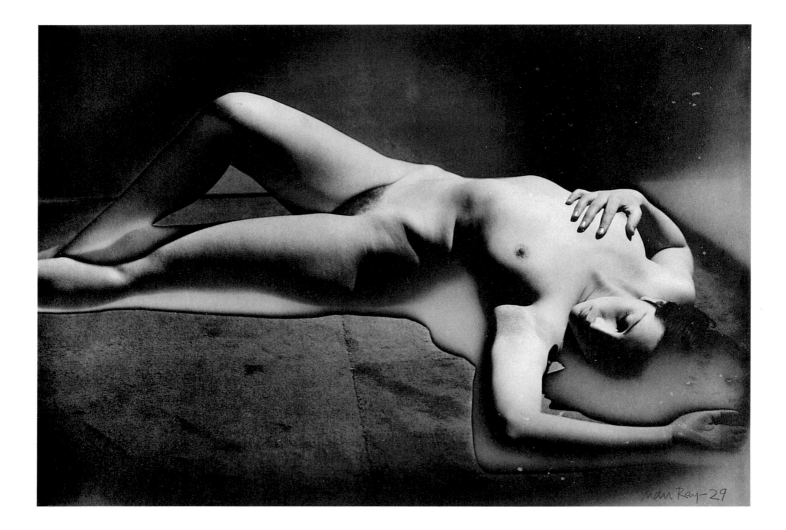

68. MAN RAY, 1929

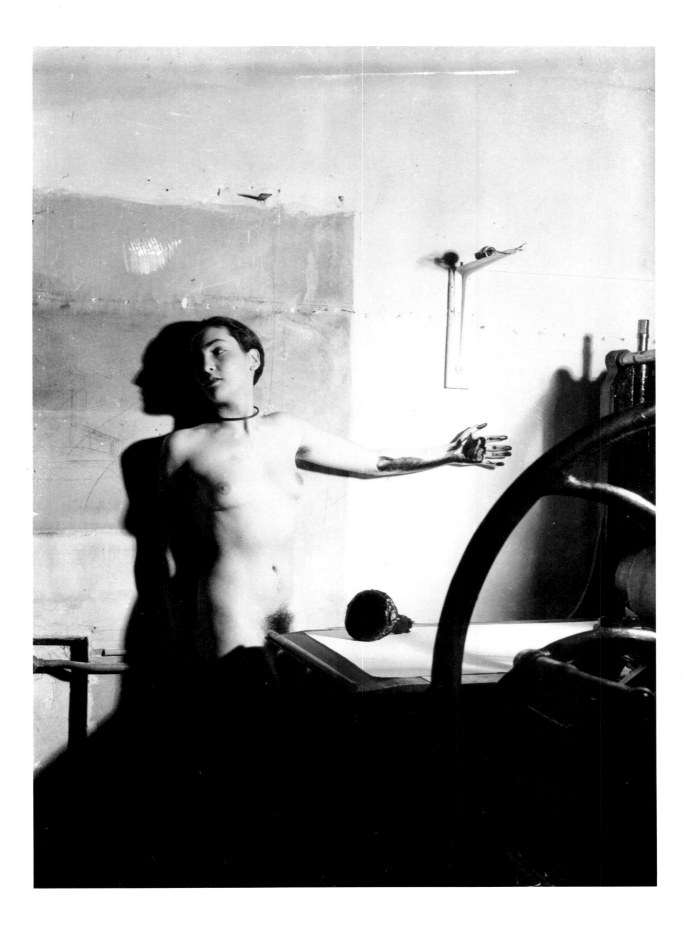

69. MAN RAY, 1935

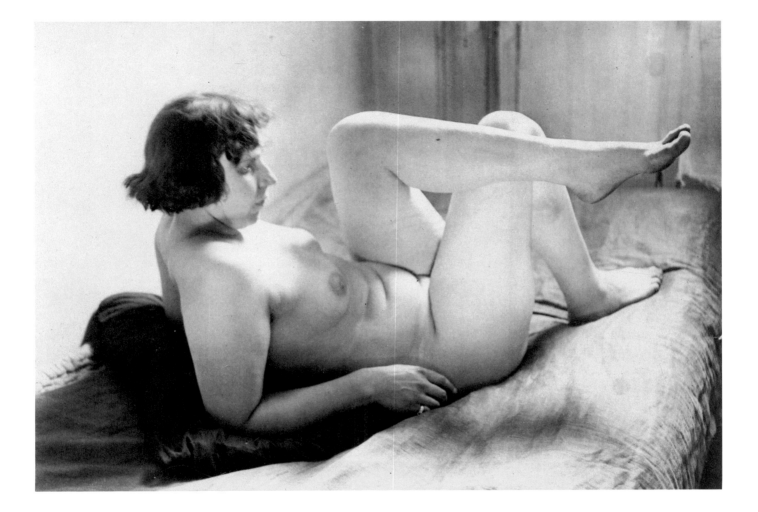

70. MAN RAY, 1920

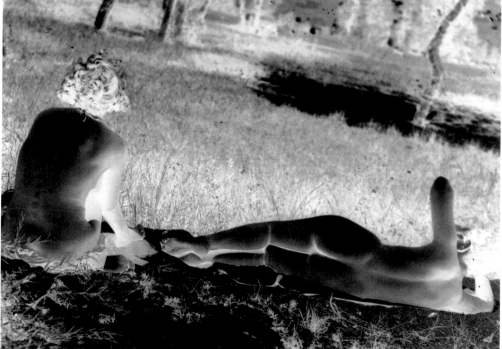

71. LÁSZLÓ MOHOLY-NAGY, *circa* 1925

72. LÁSZLÓ MOHOLY-NAGY, *circa* 1925

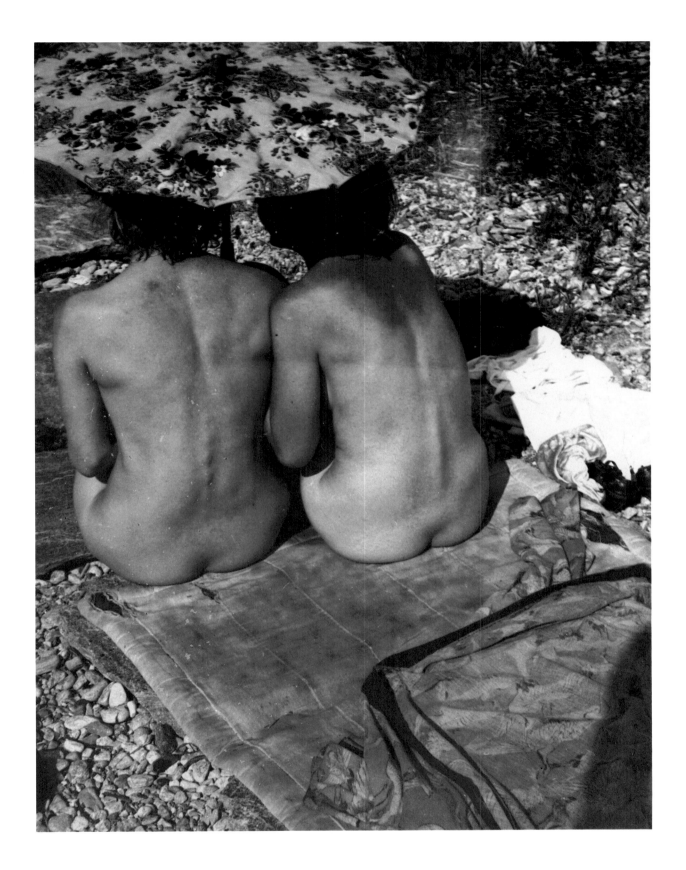

73. LÁSZLÓ MOHOLY-NAGY, *n.d.*

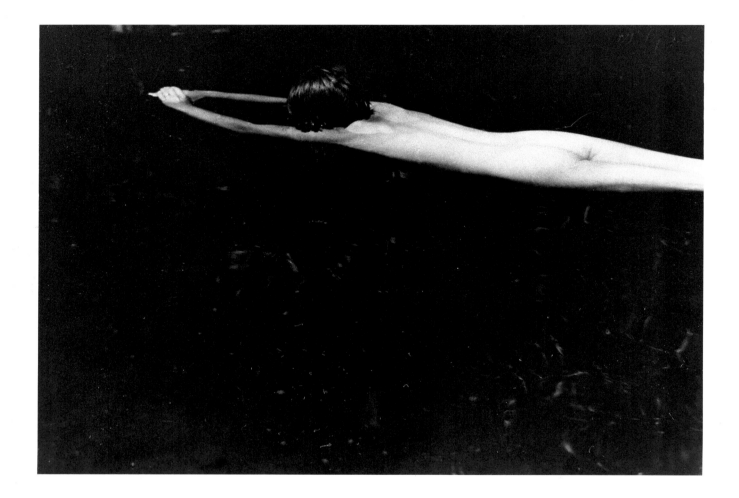

74. DOROTHEA LANGE, 1930

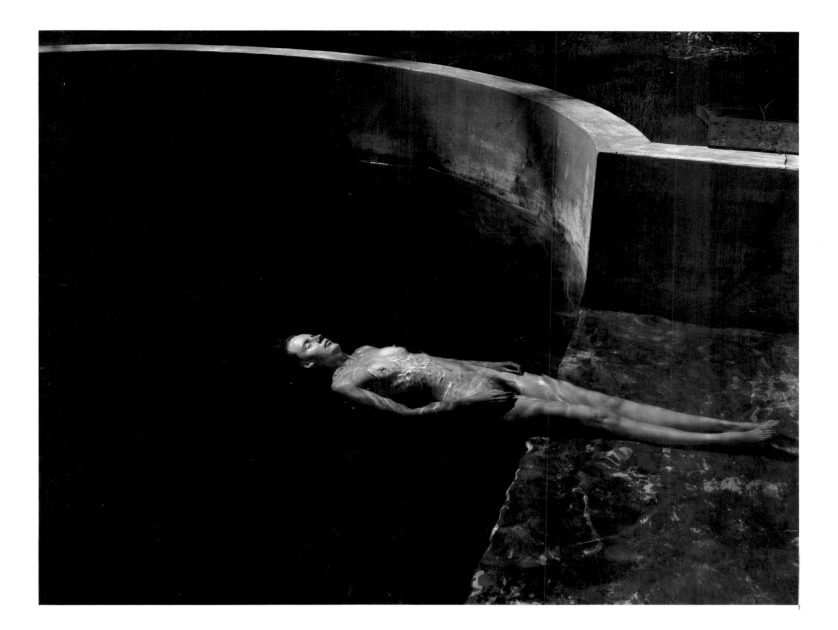

75. EDWARD WESTON, 1939

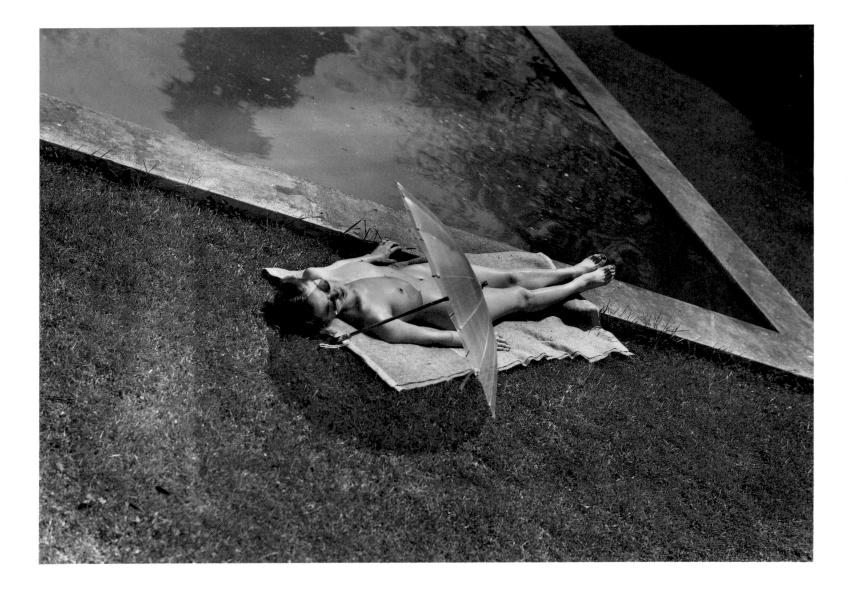

76. MARTIN MUNKACSI, 1935

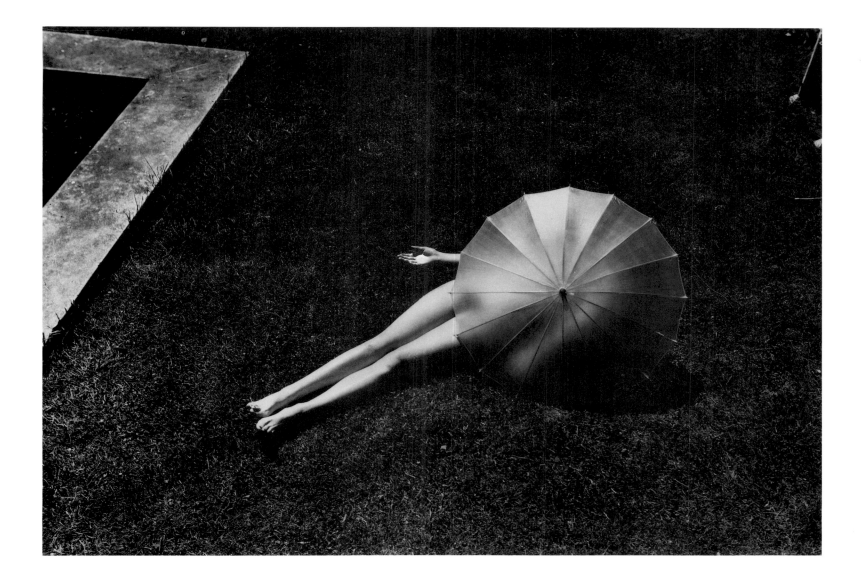

77. MARTIN MUNKACSI, 1935

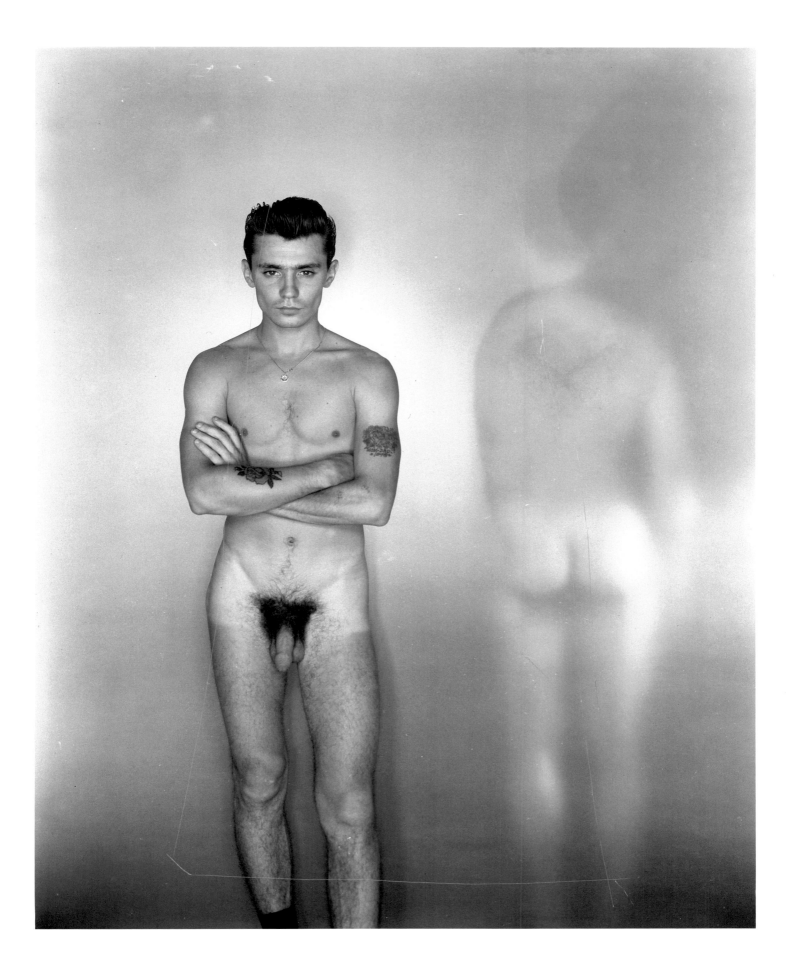

79. GEORGE PLATT LYNES, *circa* 1930

80. ROGER PARRY, *circa* 1929

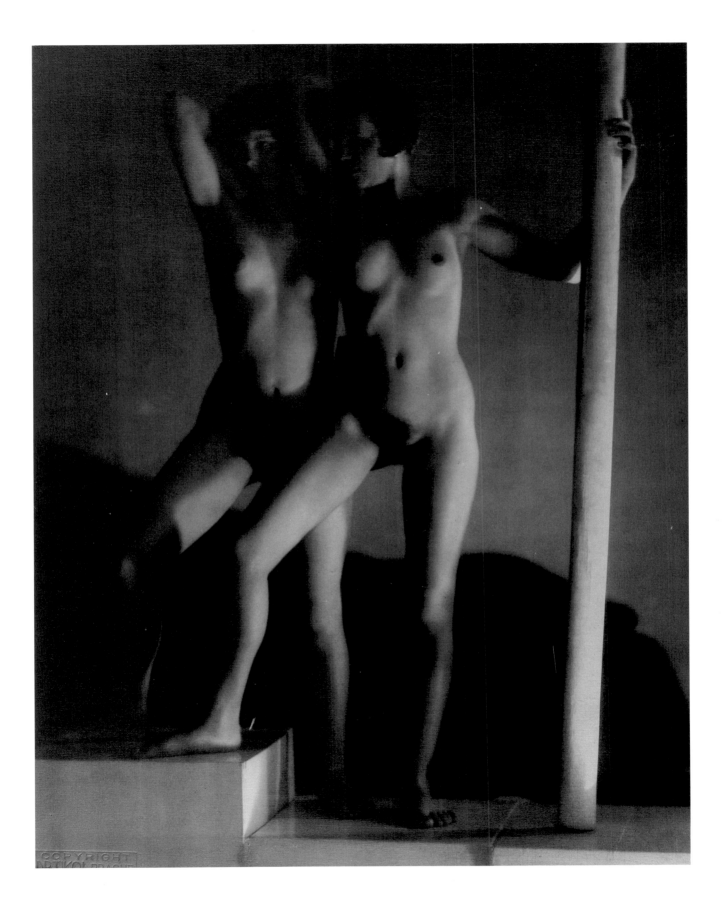

81. FRANTIŠEK DRTIKOL, *n.d.*

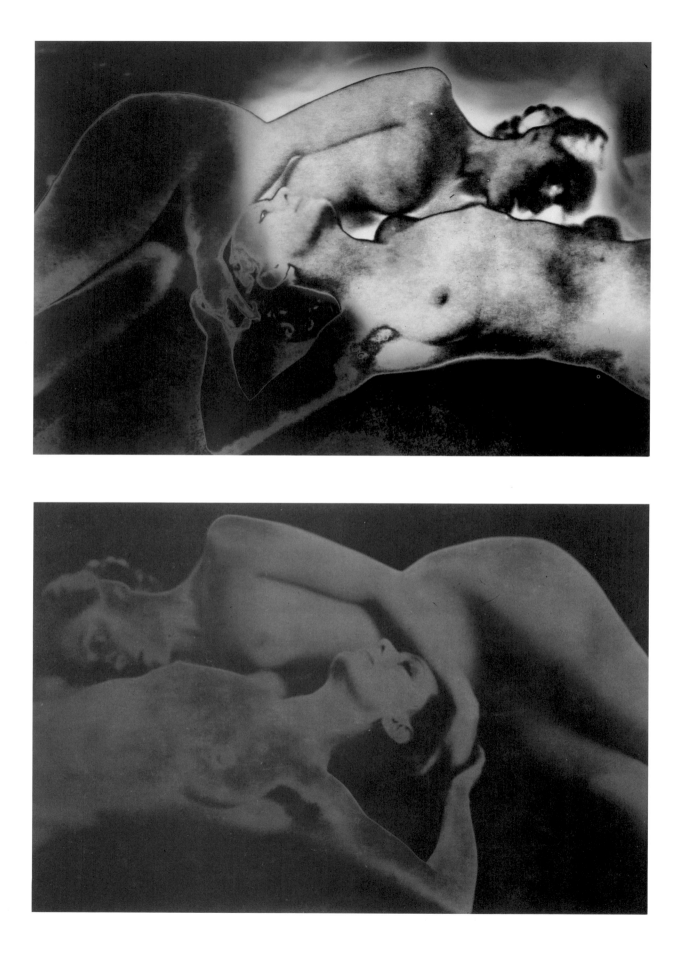

82. FRANCIS BRUGUIÈRE, 1925

83. FRANCIS BRUGUIÈRE, 1925

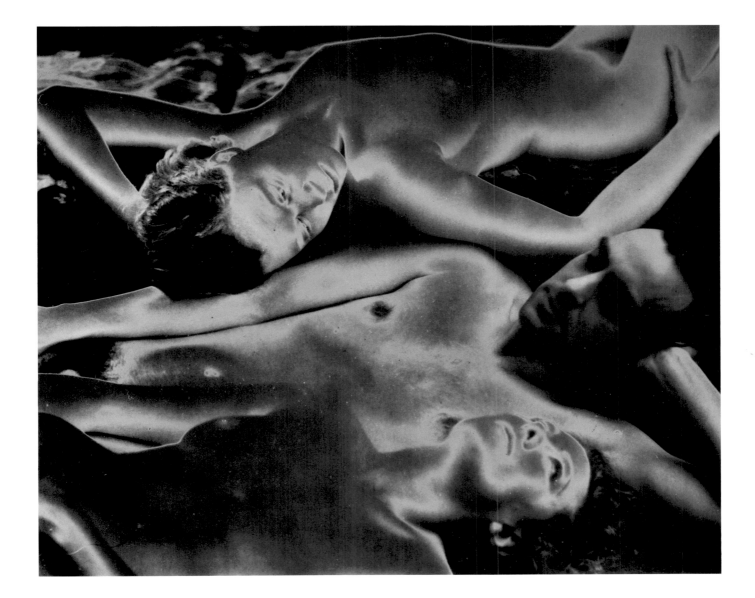

84. FRANCIS BRUGUIÈRE, *n.d.*

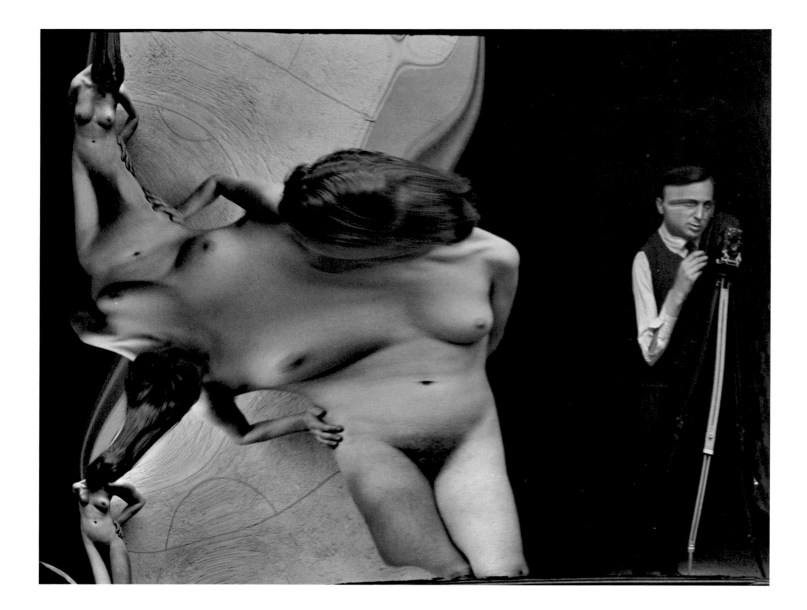

85. ANDRÉ KERTÉSZ, 1933

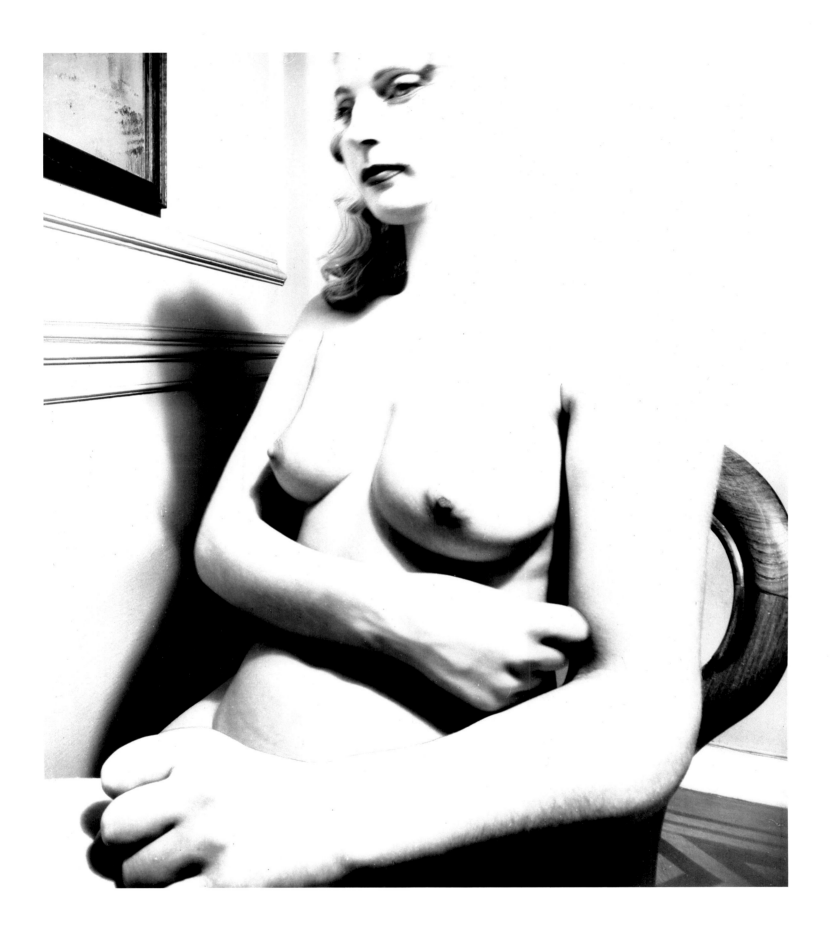

86. BILL BRANDT, 1956

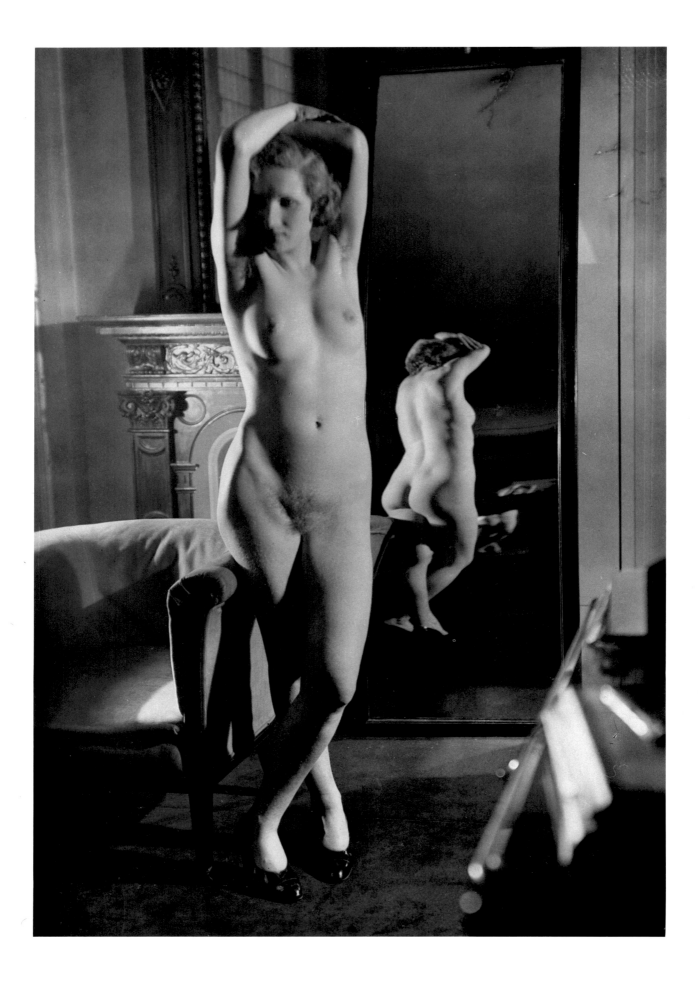

87. ANDRÉ KERTÉSZ, 1933

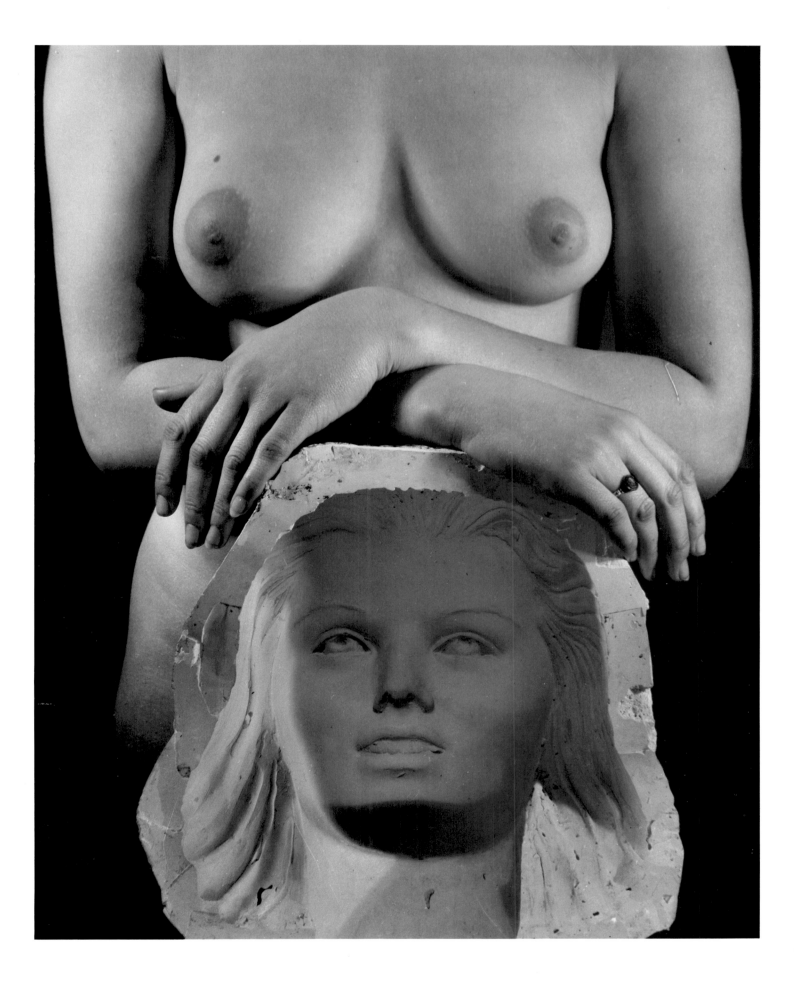

88. ANDRÉ KERTÉSZ, 1939

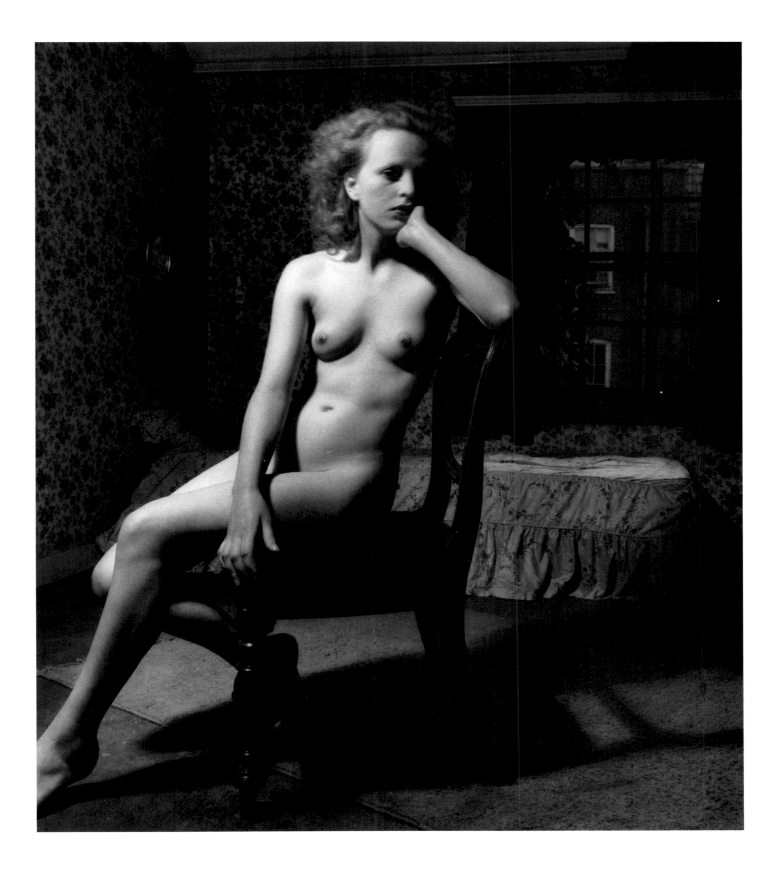

89. BILL BRANDT, *n.d.* 1975

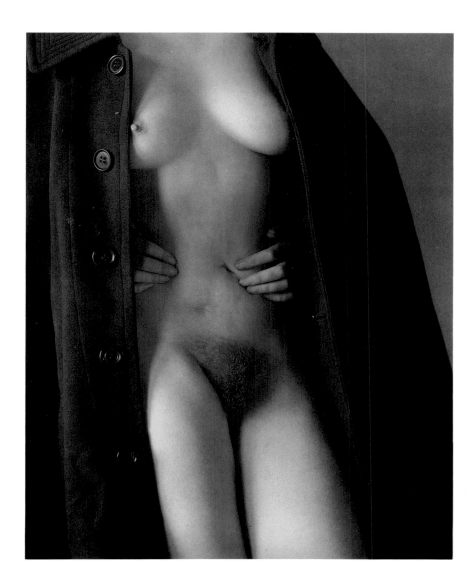

90. EDWARD WESTON, 1934

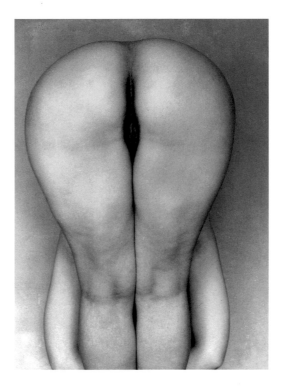

91. EDWARD WESTON, 1933

92. EDWARD WESTON, 1928

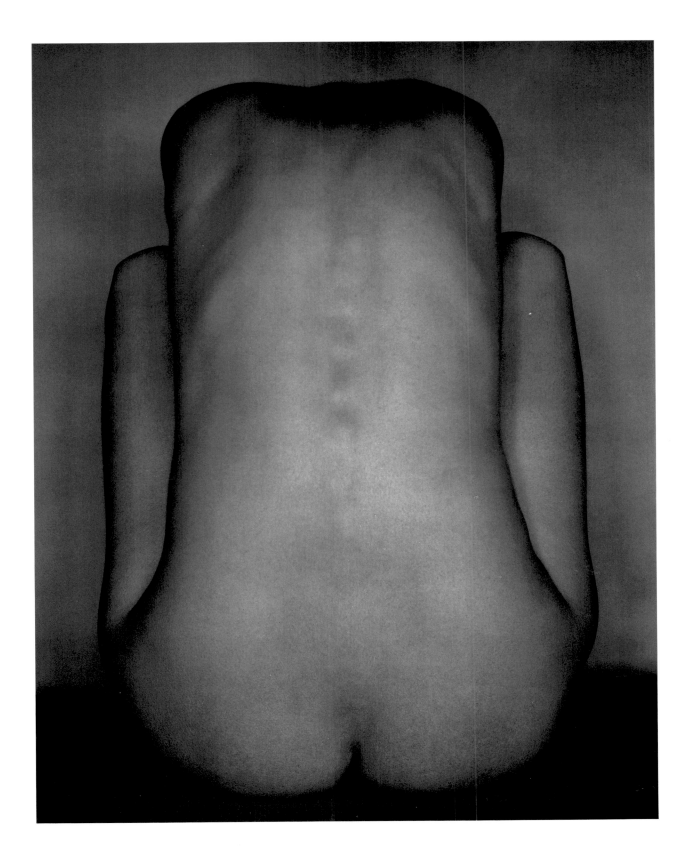

93. EDWARD WESTON, *n.d.*

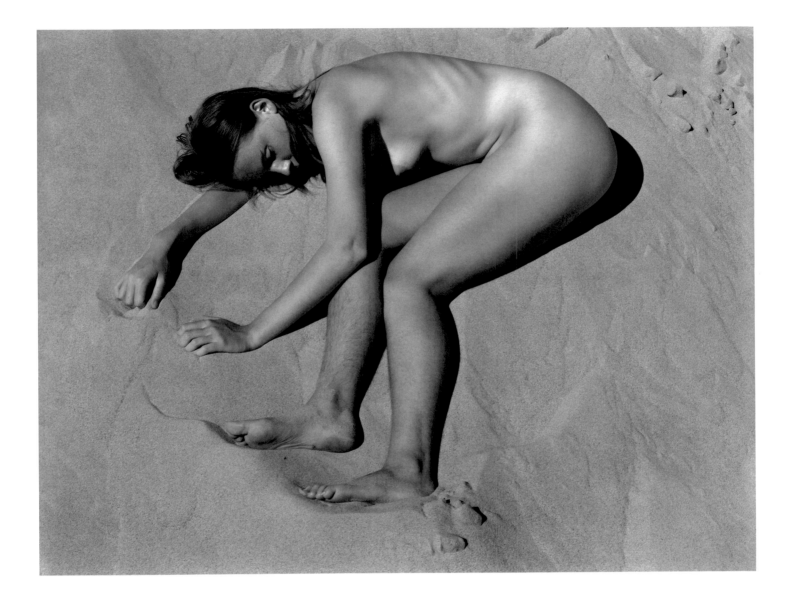

94. EDWARD WESTON, 1936

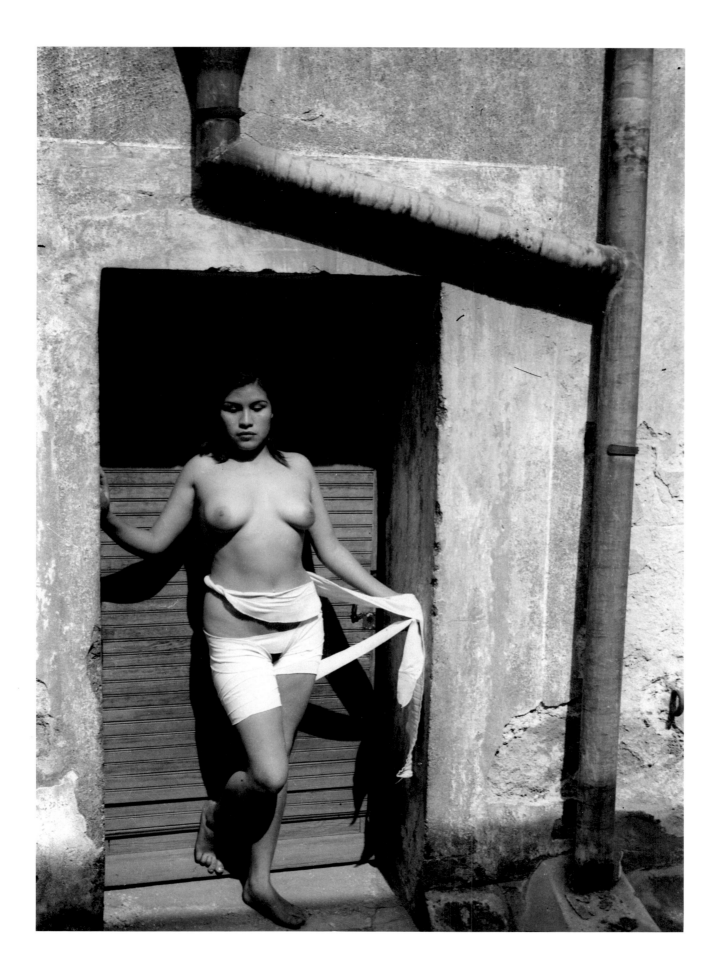

95. MANUEL ALVAREZ BRAVO, 1938

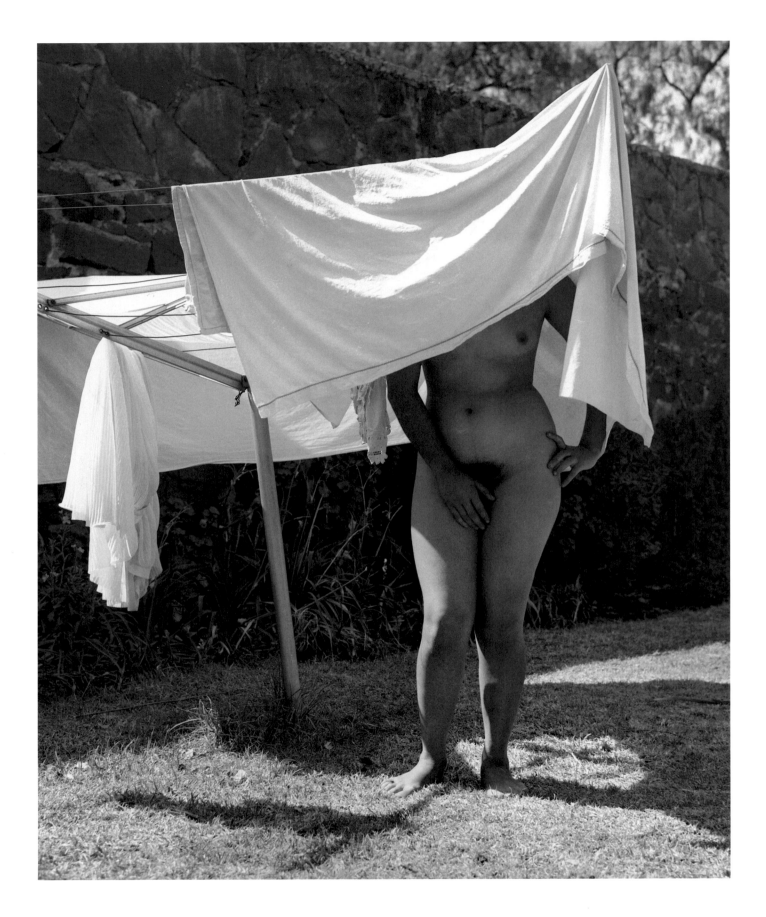

96. MANUEL ALVAREZ BRAVO, 1970

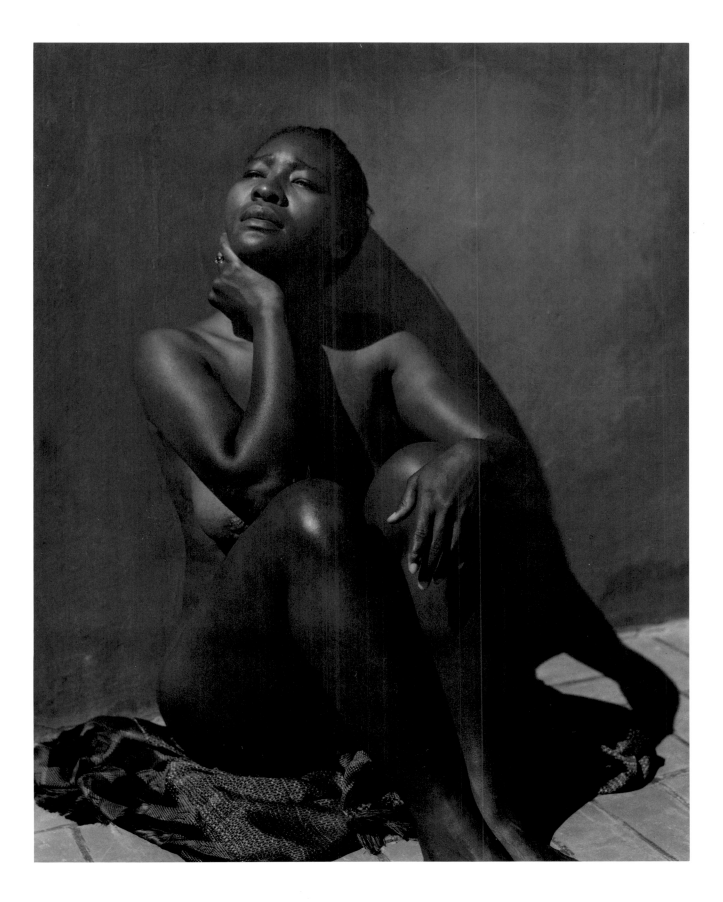

97. MANUEL ALVAREZ BRAVO, 1959

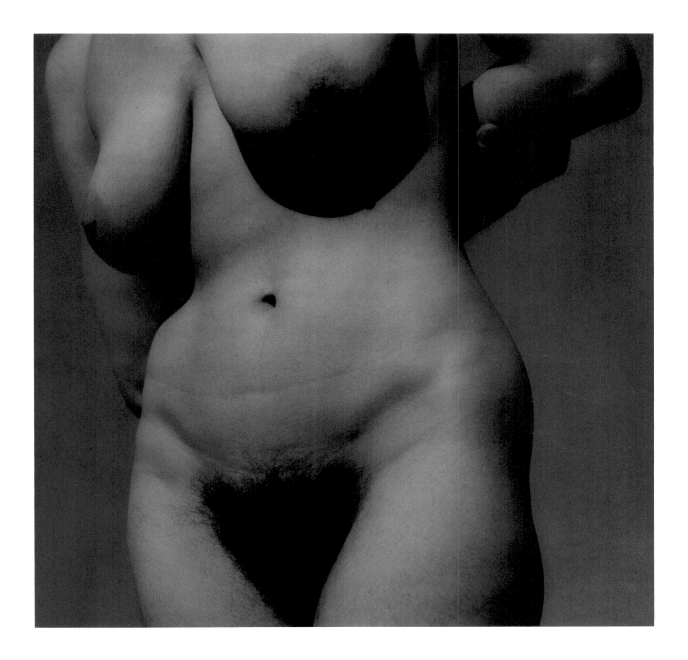

98. PAUL STRAND, 1930

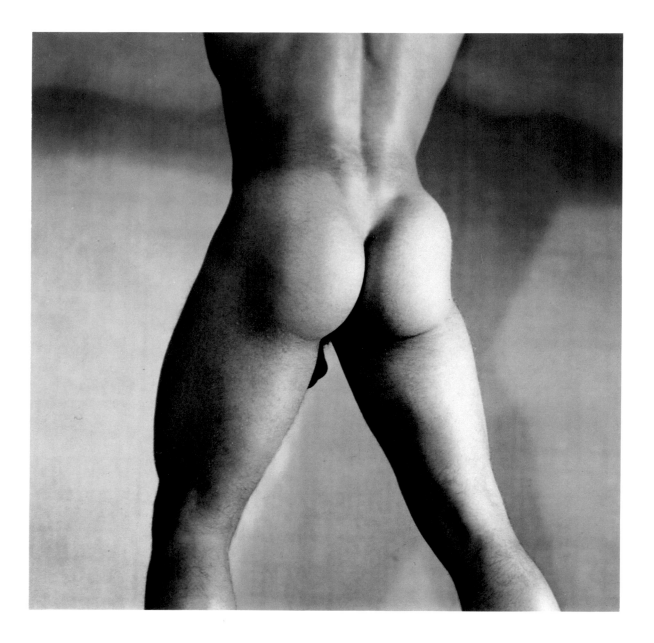

99. MINOR WHITE, 1940

100. MINOR WHITE, 1948

101. WALTER CHAPPELL, 1962

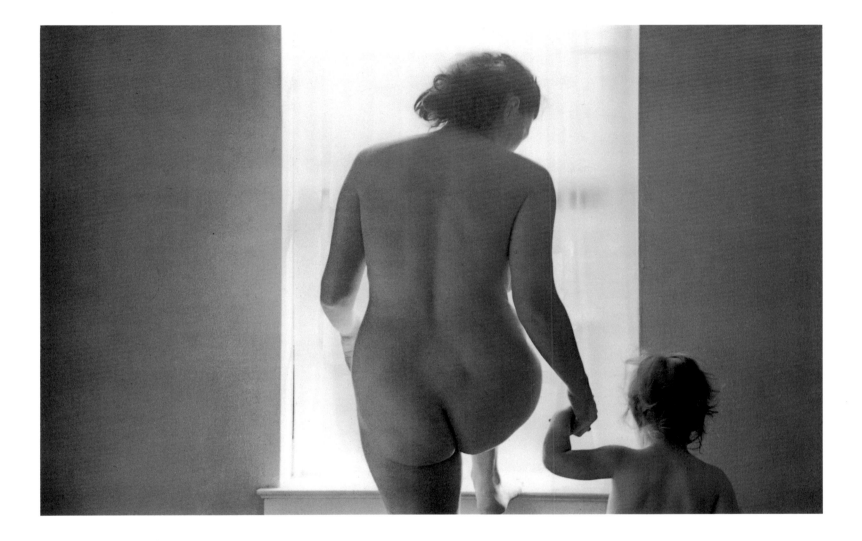

102. HARRY CALLAHAN, 1953

103. HARRY CALLAHAN, 1950

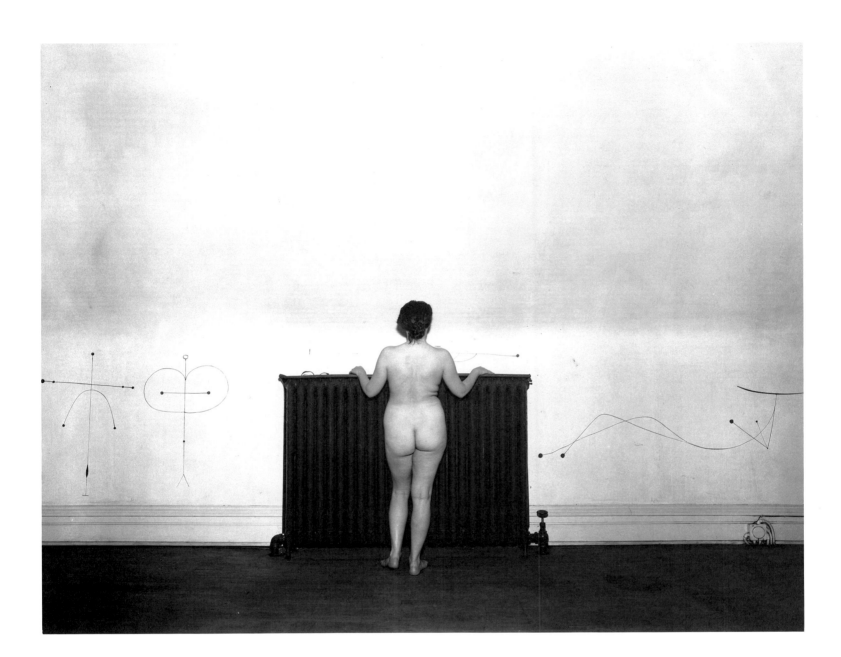

104. HARRY CALLAHAN, 1949

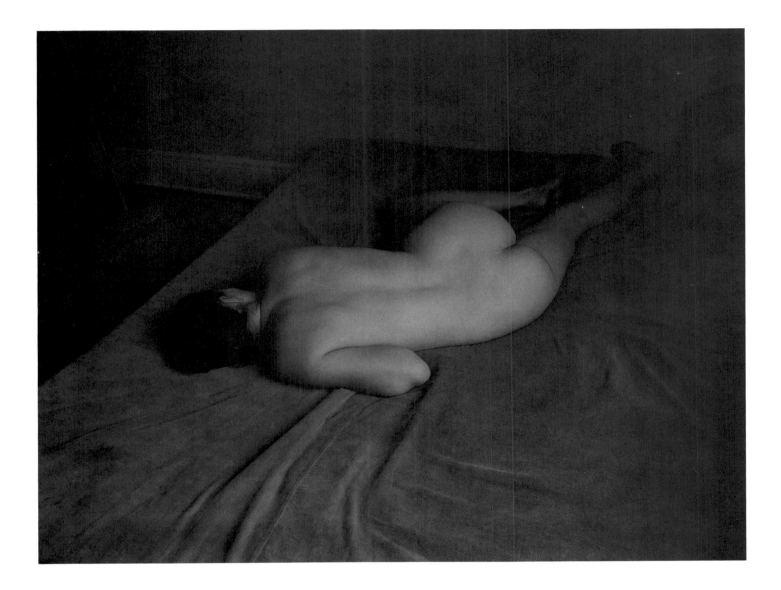

105. HARRY CALLAHAN, 1953

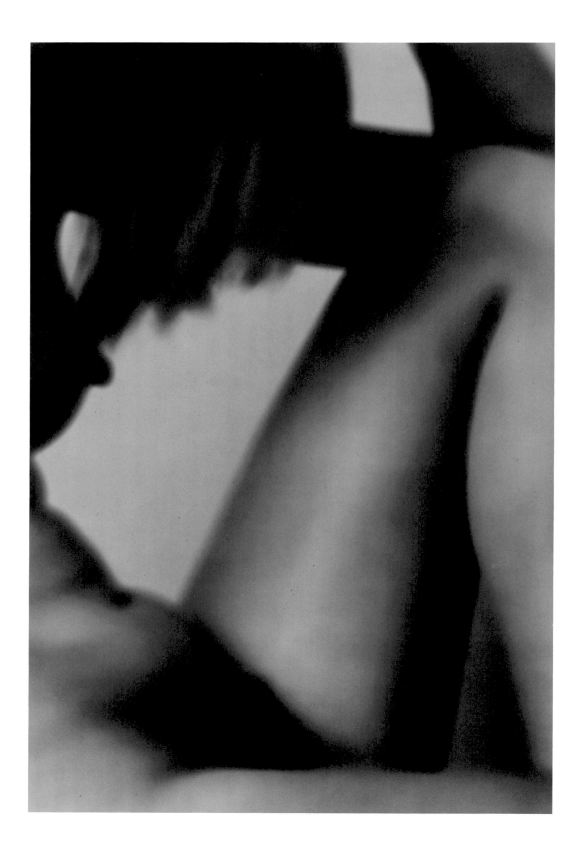

106. FREDERICK SOMMER, 1965

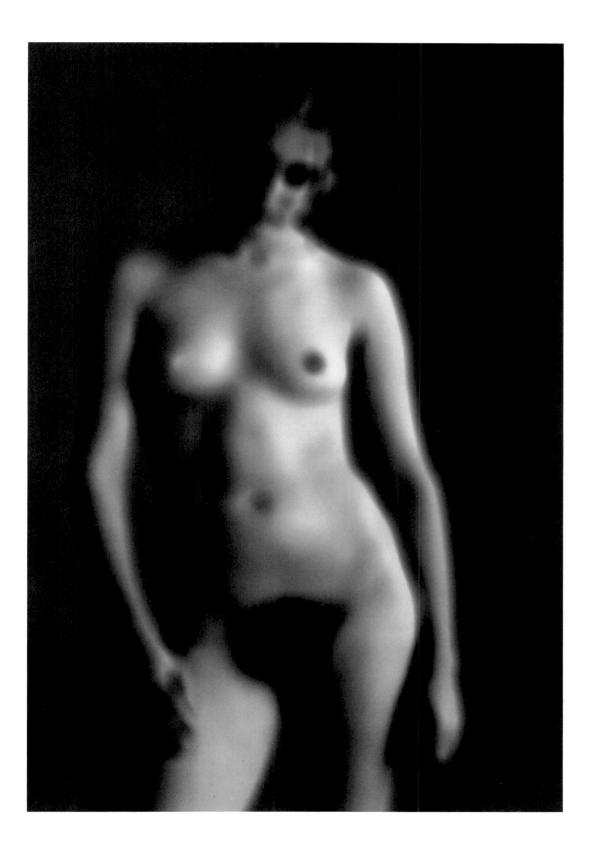

107. FREDERICK SOMMER, 1961

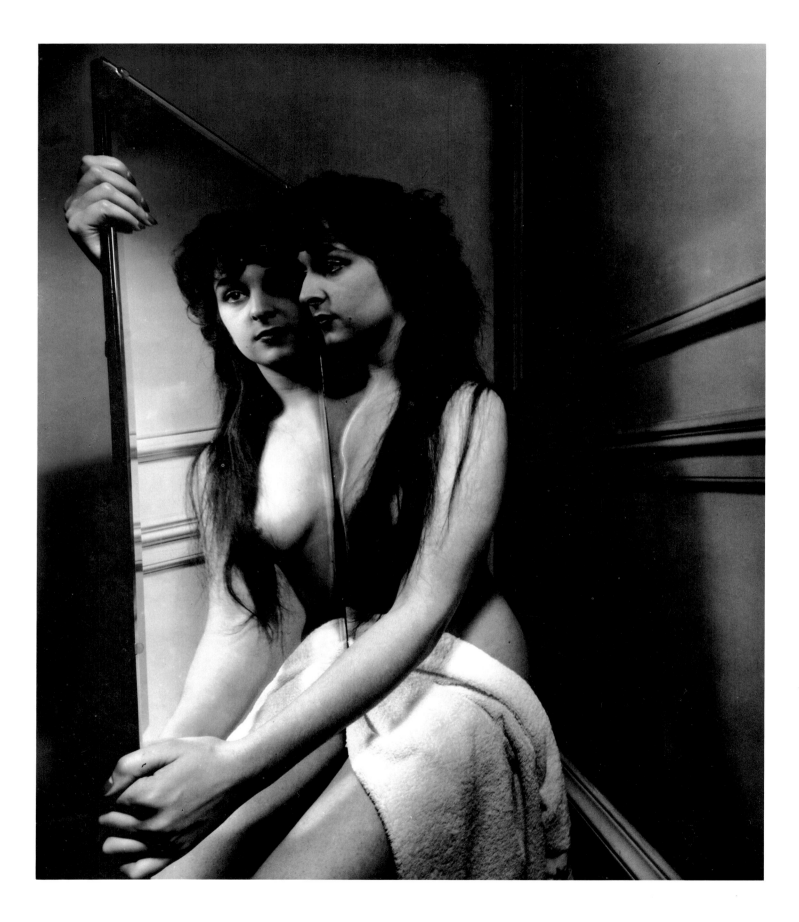

108. BILL BRANDT, 1953

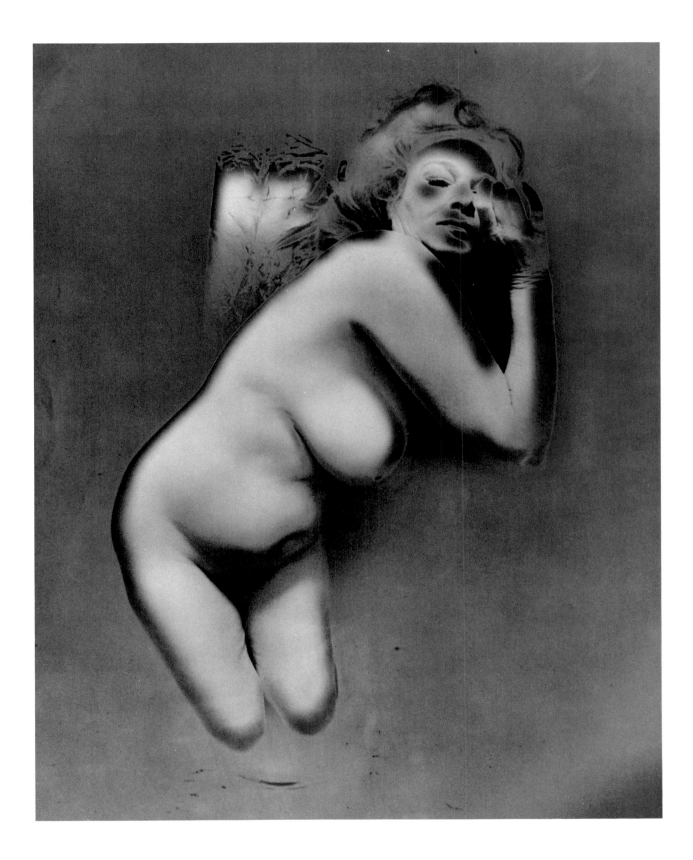

109. TODD WALKER, 1969

110. EMMET GOWIN, 1972

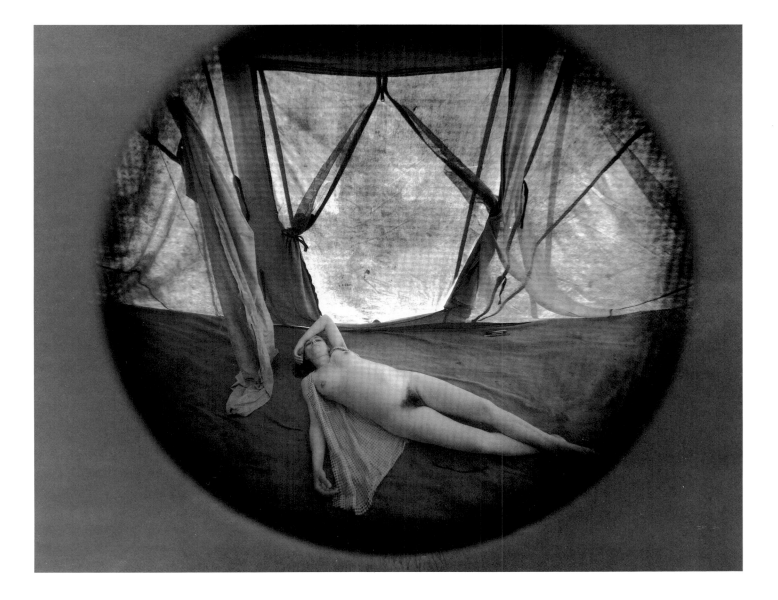

111. EMMET GOWIN, 1974

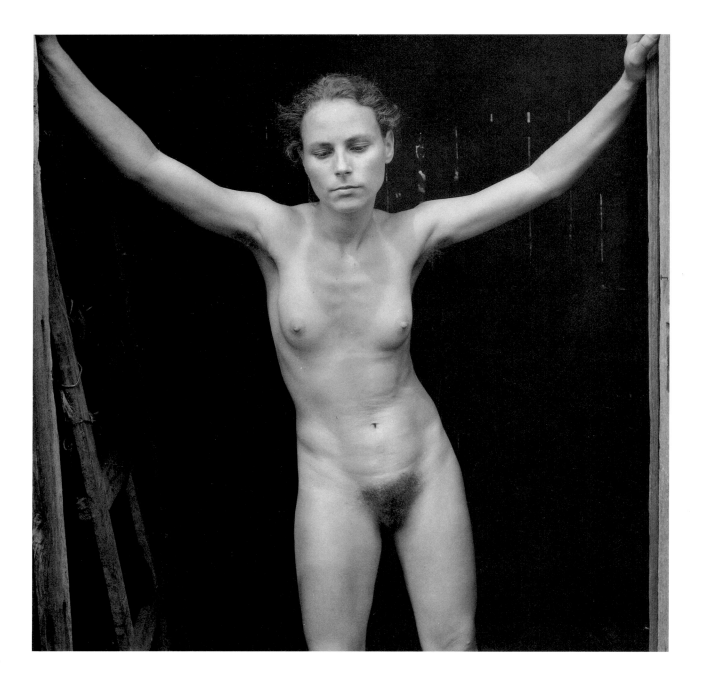

112. EMMET GOWIN, 1973

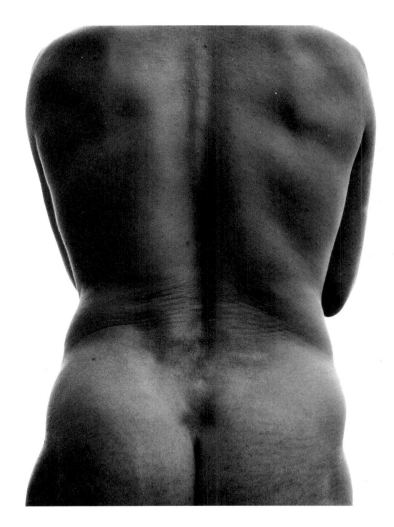

113.　AARON SISKIND, 1960

114. JOEL MEYEROWITZ, 1976

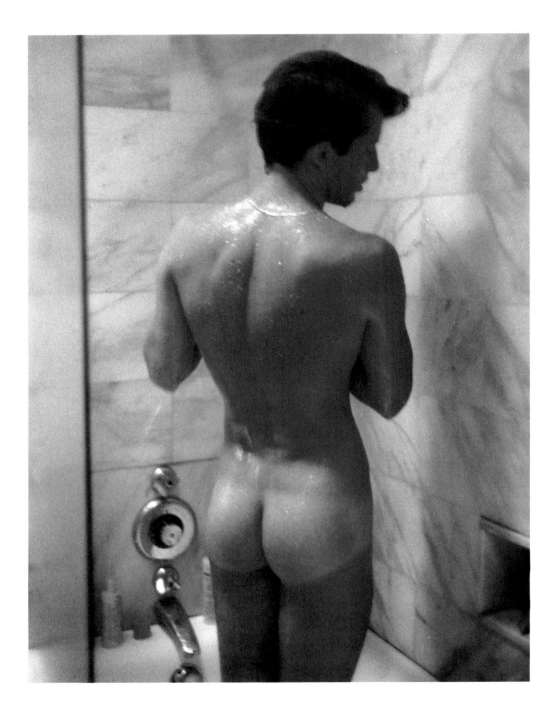

115. DAVID HOCKNEY, 1975

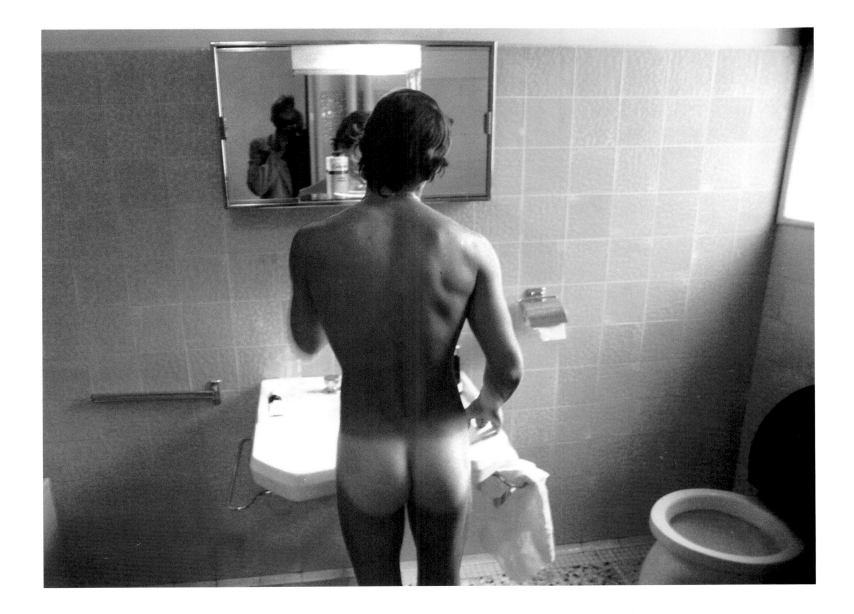

116. DAVID HOCKNEY, 1970

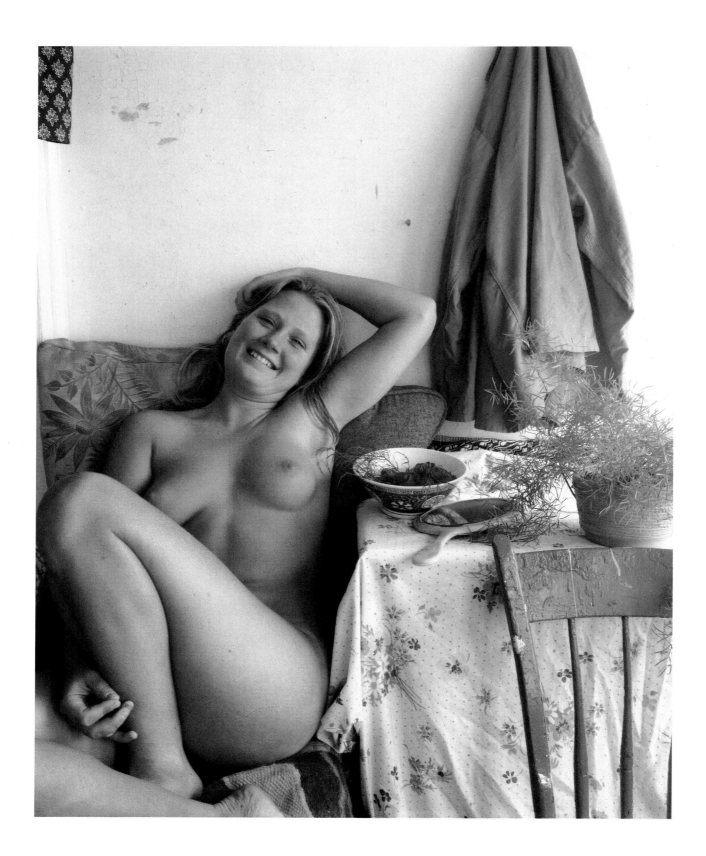

117. JOEL MEYEROWITZ, 1977

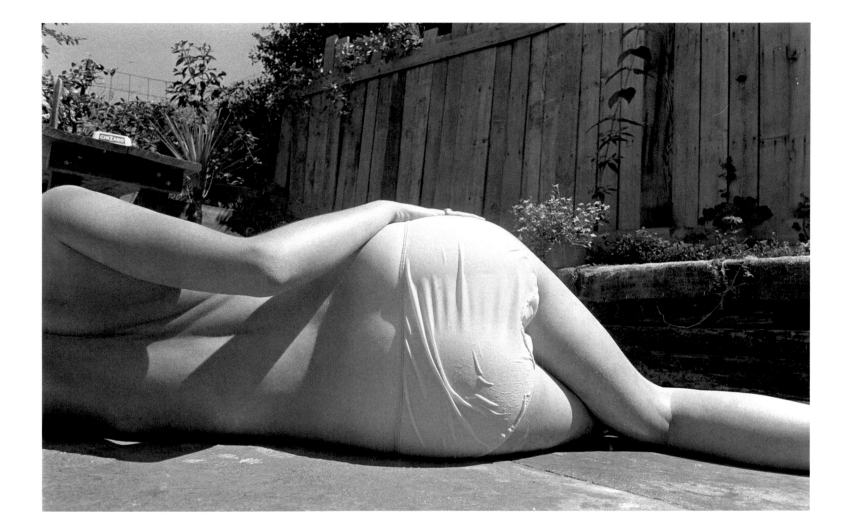

118. HENRY WESSEL, JR., 1975

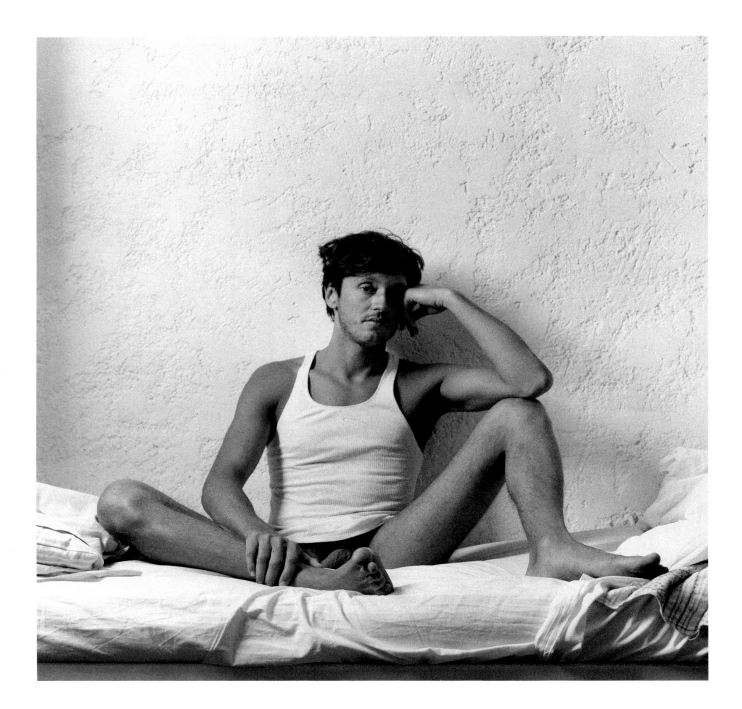

119. ROBERT MAPPLETHORPE, 1976

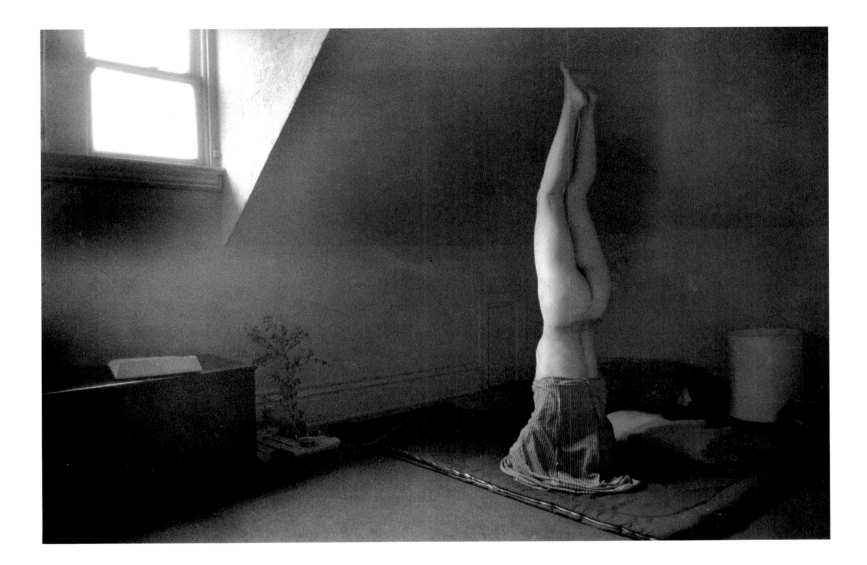

120. TOD PAPAGEORGE, 1970

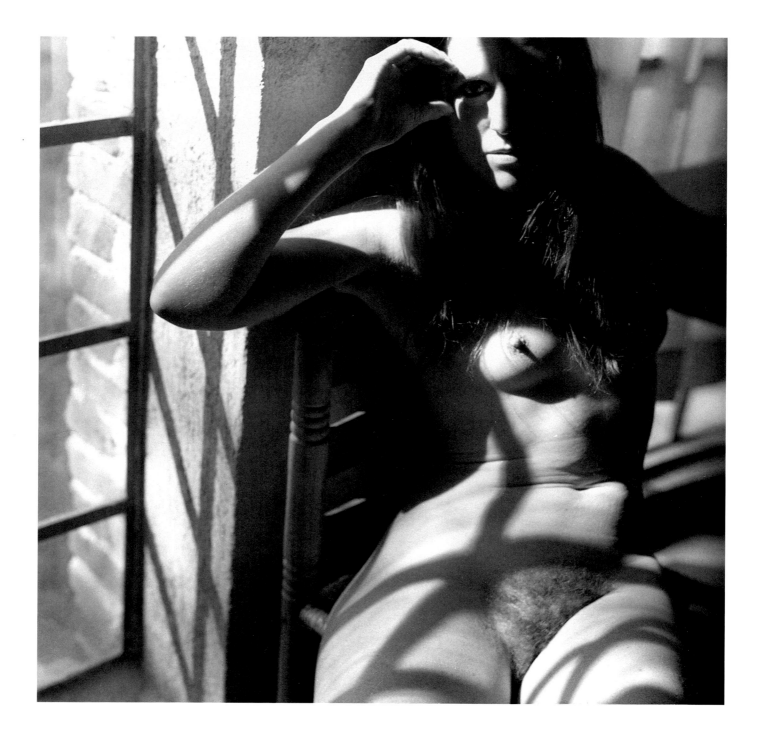

121. MANUEL ALVAREZ BRAVO, 1978

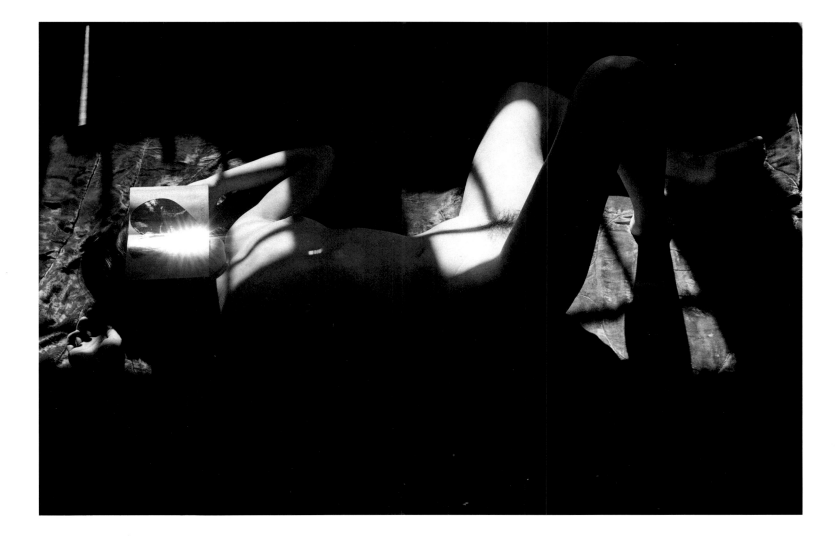

122. ROGER MERTIN, 1969

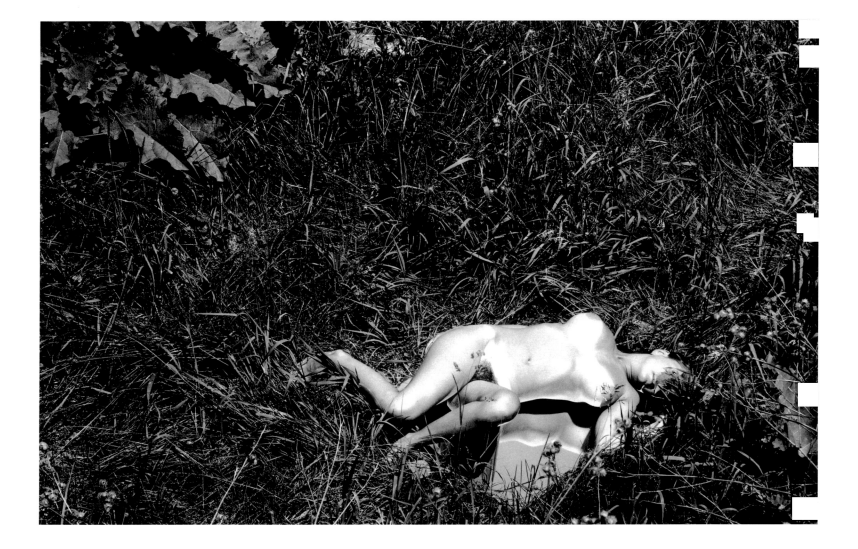

123. ROGER MERTIN, 1968

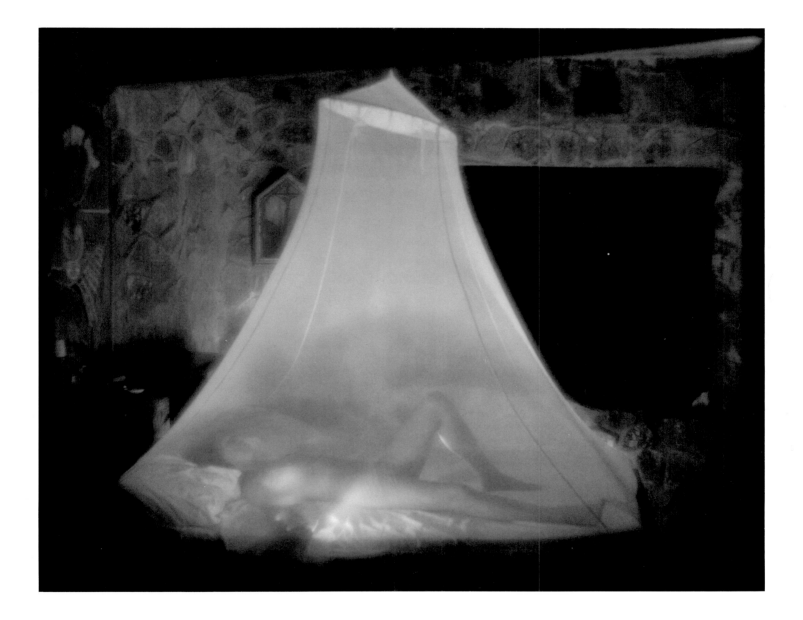

124. LINDA S. CONNOR, 1976

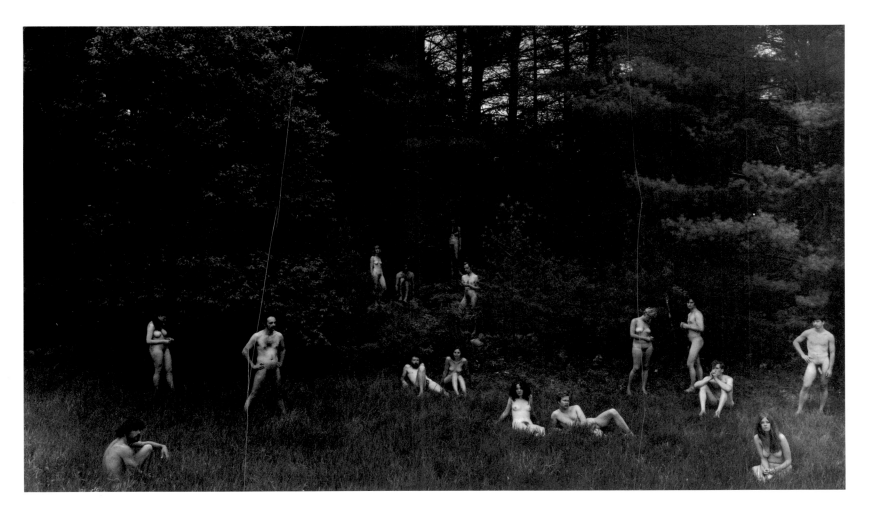

126. ART SINSABAUGH, 1969

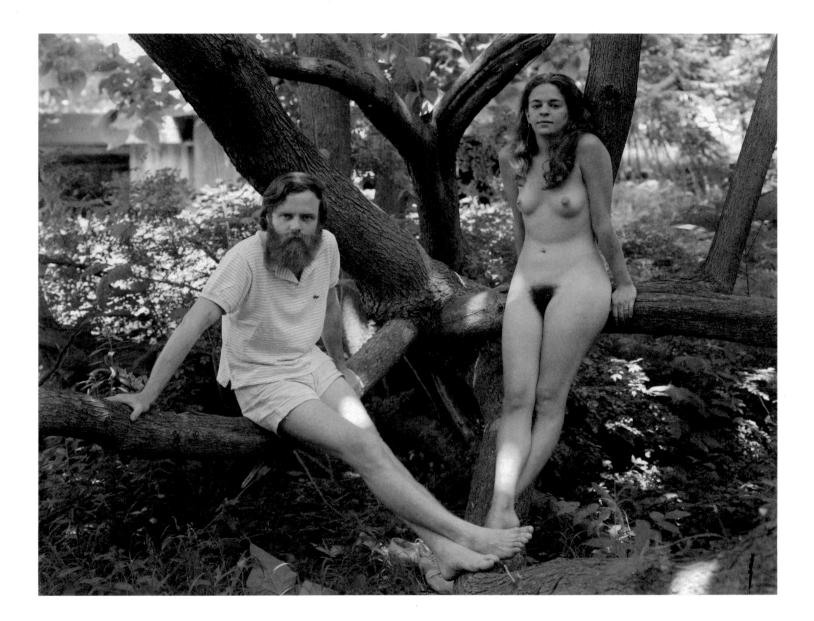

127. RICHARD BENSON, 1969

128. WILLIAM EGGLESTON, *circa* 1971

129. RICHARD PARE, 1979

130.　RICHARD PARE, 1977

131. RICHARD PARE, 1978

132. ROBERT HEINECKEN, 1974

133. ROBERT HEINECKEN, 1974

ADDRESSING THE EROTIC: REFLECTIONS ON THE NUDE PHOTOGRAPH

ROBERT SOBIESZEK

In the *Essay Concerning Human Understanding* (1690), John Locke posited a metaphor for knowledge based on an analogy between the human mind and the *camera obscura*, a darkened room or a viewing box not unlike a modern camera. Images would be focused upon a plane within the box by an aperture or lens; these images would then be viewed with great delight (Talbot called them *"fairy pictures"*) or traced by artists onto paper.[1] For Locke, ideas themselves were like these images, entering the mind through the senses and forming understanding by their accumulation. *"Would the pictures coming into such a dark room but stay there, and lie so orderly as to be found upon occasion, it would very much resemble the understanding of a man, in reference to all objects of sight, and the ideas of them."*[2] During the Classical periods of the seventeenth and eighteenth centuries, the images entering a *camera obscura* were not able to "stay there" and be physically recorded. It took the nineteenth-century inventors of photography, like Louis Jacques Mandé Daguerre and William Henry Fox Talbot, to make these images permanent. But the camera's images were not just records of the external world in a Lockean sense. They were signs of what was perceived and the direct correlation to perception. Seeing only what we comprehend, we photograph only what we perceive and, in turn, our perception and understanding are both verified and created by the photograph. The photographic image not only informs our understanding, it is the objectified token of that understanding, functioning as an externalization of our mental imagery.

In the same way, the erotic photograph is the camera realization of sexual desires and erotic dreams. Eroticism itself is a sensibility whose locus is within a conceptual zone of the mind rather than a physical exertion of the flesh. Eroticism in literature, from De Sade to Nabokov, has been both a cause of such fantasized images and a reflection of them. When the youthful Gustave Flaubert wrote, *"Oh, how willingly I would give up all the women in the world to possess the mummy of Cleopatra,"*[3] he was expressing a sincere fascination with a mental, erotic fiction rather than a serious interest in a necrophilic passion. The depiction of erotic themes in painting and sculpture, likewise,

evokes and portrays an interior image, an image brought into being by both creator and viewer. The inner imaging of the sexually evocative is the fundamental essence of eroticism and desire: the nominator of erotic pleasure is always formed by the denominating idea about that pleasure. More than in any other graphic medium, eroticism in photography is linked to the subject and its objectification. A photograph of a nude is both of an erotic subject, the nude, and an erotically functional object, the photographic image. It is a pictorial product of the erotic imagination and an agent provoking an erotic response.

Just as imaginative constructs may range from the base and repulsive to the ideal, so erotic photography may include the pornographic or the aesthetically spiritual. The distinctions depend simply on available norms and permissions, either personal or social. There are, however, two striking differences between pornography and eroticism in photography. First, the forms as well as the contents of pornography have not significantly changed since the first hard-core pornographic photograph was made. Kurt Vonnegut, Jr. might have been close to accurate in representing the origins of pornographic photography with his apocryphal assistant to Daguerre, André Le Fèvre, who was arrested and imprisoned for selling a daguerreotype of a woman coupling with a Shetland pony.[4] Le Fèvre and his daguerreotype were theoretically possible in 1841, but, except for the difference between still and motion pictures, there is little to distinguish between Le Fèvre's image and *Horsing Around Behind the Barn*, the 200-foot reel issued in the 1960s and featuring Tricia and her pony, Blackstrap. In more than one respect, pornographic photography can be compared to real-estate photography: the particulars of the content constantly change but the intent, the function and especially the style of the imagery remain the same.

The second distinction between pornographic and erotic photography further concerns the beginnings of this modern medium. Pornographic photography is primarily traditionless; it simply depicts the subject matter of literal pornography, from uncomplicated coitus to much of Sadean "perversity." Erotic photography, on the contrary, is inextricably linked to a

specific literary origin and a psychological heritage of erotic recollection. During the century before photography, throughout the pre-photographic beginnings of the camera's image, there is no mention or even hint of any *pornographic silhouettes* or *camera obscura* drawings. There is, however, an *erotic* fiction surrounding the origins of pictures.

According to Greek legend, sponsored primarily by Pliny the Elder, the beginning of painting is found in the story of Dibutade and her lover. Due to leave for battle the next morning, Dibutade's lover fell asleep next to a lamp. Anxious to preserve a faithful likeness of him as a romantic souvenir, the Corinthian maid traced his silhouette as it was projected onto a nearby wall. This story, vigorously revived in the 1770s, was continued well into the romantic era and frequently transposed to signify the invention of fashionable portraiture in the modern world, such as silhouettes themselves.[5] Not only was Dibutade's portrait of her lover formed by the agency of light, as is the photograph, but the association between her image and the coveting of a romantic, pictorial memento were easily transferable to photography. By the 1850s, a typical advertisement for stereographic portraits would read:

> *By this improvement, husbands, will, when thousands of miles separate, be enabled to see their wives standing before them in breathing beauty, wives their husbands, and lovers their sweethearts . . . it will enable us to see them as they once were with us.*[6]

From these mythic origins, erotic photography has seen a continuing change and development of many divergent styles through the decades. These changes have been inspired as much by art and aesthetics as they have by social, economic and technological factors. The common denominator of all these images remains the need to provoke the idea of pleasure. The image cues the reverie and sparks the erotics of the imagination, the same as it surely assisted the memory of the Corinthian maid.

In his work on the nude in art, Kenneth Clark distinguished between the naked and the nude.[7] For him the difference lies in the degree of mental idealism forced on the form. The more idealized and purified, and thus "nude," a form is, the closer to a work of art it is. The particulars of any specific nude are extraneous to the ideal of nudity; therefore, the greater the idealized perfection the figure exhibits, the more it approaches an aestheticized and internalized vision of the nude. One of the most frequent criticisms of nude photography during the nineteenth century was not that the figures were unclothed, but that they were ugly and imperfect. The human was not perfect enough to meet the expectations of art. This criticism had little to do with how the models actually looked; rather, it had to do with how their looks contrasted with an abstract model of beauty. But in photography, no ideal human form is materially present to photograph, since the medium does not directly deal with mental perfections so much as with (often coarse) reality. It just might be, then, that in specifically photographic terms, the very nature of the erotic photograph—its blatant dependence on material nature—is its merit as an evocative and provocative object. It may yield its own, more modern ideal, founded more on particular fact than any predetermined notion of perfection.

THE first nude photographs were not necessarily of living beings. A fair number of early stereoscopic daguerreotypes are of classical nude statuary, such as Venuses and Aphrodites, which could easily be posed before the camera (and demand no model fees). While models for painters had to pose unclothed for long periods of time, often braving the cold of the artist's studio, after 1841 exposure times were reduced sufficiently to allow photographing live models in some comfort. One of the very first documented photographic self-portraits on paper is by the Frenchman, Hippolyte Bayard, dated 1840, in which he is posed as a half-nude corpse. The picture was made as a sarcastic rebuff of the French government's patronage of Daguerre at the expense of Bayard, who also independently invented photography. This early photograph, however, forces some consideration of the connection between the images of sex and those of death. According to De Sade, *"There is no better way to know death than to link it with some licentious image."*[8] Another

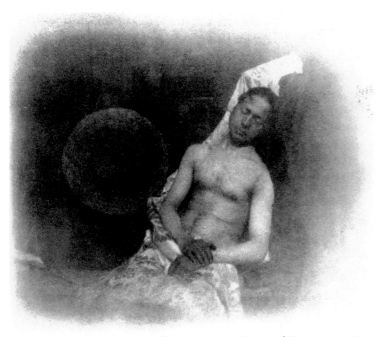

HIPPOLYTE BAYARD. *Self-portrait as a Victim of Drowning.* 1840. Courtesy of the Société Française de Photographie, Paris. International Museum of Photography at George Eastman House, Rochester, New York.

French writer, Georges Bataille, stated this principle more fully.

> *In essense, the domain of eroticism is the domain of violence, of violation. . . . What does physical eroticism signify if not a violation of the very being of its practitioners?—a violation bordering on death, bordering on murder? . . . The whole business of eroticism is to strike to the inmost core of the living being, so that the heart stands still. . . . The whole business of eroticism is to destroy the self-contained character of the participators as they are in their normal lives.*[9]

The similarities between viewing photographs of sexual subjects and those of death and violence are many, and constantly reaffirmed throughout the history of erotic photography. The sexual subject as image is a functional symbol much akin to the image of a dead person, where the subject is so objectified that he or she is presented to be manipulated by the viewer's imagination. The mechanics are really the same in both cases: initial shock of recognizing the subject; objectification of that subject or critical distancing from it; fascination with the details and our reactions

to them; personalization of a relationship to or with the subject; and, finally, a self-questioning about that relationship and a kind of Brechtian critical catharsis.[10]

An image of an erotic object is a negation of the object's essential character or humanity. In an interview published in 1966, Alain Robbe-Grillet, the author of *Le Voyeur* and *Instantanés*, discussed the nature of the erotic photograph. *"In reality,"* he claimed, *"a woman exists for a man only in the forms devised in his mind."*[11] She is abstracted into a mental reality from the object he sees her as, and at the moment of making a photograph, the female model is transfixed and thus transformed into the image. She is *"frozen in a pose which is not the model at all, but the image born in the imagination of her male partner."* The model thus becomes a token of nature, an objectified artifice that allows the viewer to handle her mentally and to fantasize about her; the human becomes a mannequin, a doll, that *poupée* so dear to the surrealists. Robbe-Grillet was fairly rigid in his treatment of genders, but there is no reason to suspect that the same process does not occur if the sexual roles are reversed.

The history of erotic photography is precisely the history of such mental objectification with pictures and the underlying tension between the aesthetic and the sexual. The erotic photograph is a functional image with its most direct reference to material reality only at the time the photograph was made. Once created, however, the objective correlative ceases to exist, and the image refers directly back to itself. The referent is absorbed by the photograph. The photograph is, in turn, both the product of the artist's controlling vision and a function of the viewer's fantasy manipulation. *"To photograph is to appropriate the thing photographed,"* signaled Susan Sontag. *"It means putting oneself into a certain relation to the world that feels like knowledge—and, therefore, like power."*[12] The hero of Kobo Abé's *The Box Man* intuitively understood this calculus of photographing and the imagination.

> *Her naked body was far more charming than I had imagined it to be. It was natural; there was no question of my imagination being able to catch up*

with her actual nakedness. Since this nakedness existed only while I was looking at it, my desire to see it became poignant too. Since it would vanish the minute I stopped looking, I should photograph it, or get it down on canvas. The naked body and the body are different. The naked body uses the actual physical body as its material and is a work of art kneaded by fingers which are the eyes. Although the physical body might be hers, concerning the proprietorship of the naked body, I had no intention of retreating in impotent envy.[13]

In essence, this is a near-perfect exemplification of the tensions at work between the corporeal reality and the mentalized imagery in erotic photography. The precise mechanism of this aestheticizing of the physical, of placing the material body at the direct service of imaginative control, might be the primary function of all photography—architectural, landscape, portrait, and so on—but it is most blatantly obvious with erotic subjects.

Nineteenth-century erotic photography was for the most part kept under wraps of illicitness or rationalized as an assistance to the artist. The majority of stereographic daguerreotypes depicting figures in the throes of various embraces were most likely circulated in an arena of surreptitious commerce. In a society that talked so much about sex while exerting such an effort to avoid naming it, when a medical-legal text of 1857 discussing sexual mores could declare that *"The darkness that envelops these facts, the shame and disgust they inspire, have always repelled the observer's gaze,"*[14] in such a climate, the detailed objectivity of these daguerreotypes was at the very least challenging. These anonymous images are really continuations of older forms of picturing human coitus, oral sex and sapphic love, only that they differ in their exceptional clarity and naturalism. They display a charm, a delightful reserve and innocence in part due to a veneration of their age and to elements like hair styles and studio columns which firmly place the subjects in their past.

In the same way, the photographic figure study, the camera made *académie*, was modern technology's answer to the time-honored hand drawn sketch. Used by painters as different as Delacroix and Eakins, these art studies, by Braquehais, Vallou de Villeneuve, Durieu and others, functioned as surrogate models to draw from and to help in determining the general composition and lighting in the larger work. Collected and looked at, they, like their more prurient counterparts, contributed to the expanding discourse about the photographic nude.

Nude photography was also at the service of the growing "scientificity" of the last century. Anatomical studies for the military, ethnographic daguerreotypes of slaves, medical photographs of deformities and time-lapse examinations of physiologies in motion were part of the new vocabulary of categories and typologies developed during the second half of the century. Science's role was to classify and it classified in order to understand, an intellectual process making those images which came into the Lockean mind permanent. Muybridge's studies of nude figures taken during the late 1870s and 1880s as well as the numerous photographic illustrations in publications like Roth's *The Treatment of Lateral Curvature of the Spine* (London, 1889) were means of endowing science with the necessary typologies for its analysis.

Parallel with the expanded use of photography in assisting this data collecting of species and types, a new and somewhat esoteric language of sexual characterization was being constructed, a vocabulary better able to explain the new information. Concepts like Krafft-Ebing's zoophiles and zooerasts, Rohleder's auto-monosexualists and even Westphal's more functional characterization of homosexuality as a psychological type were the foundations of the modern language of psychoanalysis. As such, these notions, and others, prepared the way for Freud's ideas surrounding polyperverse neurosis and his "discovery" that the neurotic locus was the mind, and not the body. *"Nineteenth century 'bourgeois' society. . . ,"* urged Michel Foucault, *"was a society of blatant and fragmented perversion. It produced and determined the sexual mosaic."*[15] Nadar's photograph of a hermaphrodite (*Plate 21*) is both a document of medical classification and knowledge and the symbol of a fascination with the eccentric zones of sexuality. Much scientific and medical photographic imagery is strange, at times

surreal and very often provocative—not only because of the *irreal* deformations and "otherness" it depicts, but more specifically because of the clinical emptiness and calculated objectification of the subject—the figure under examination. The serene compliance of the patients denotes the relinquishment of their bodies to both science and the photograph.

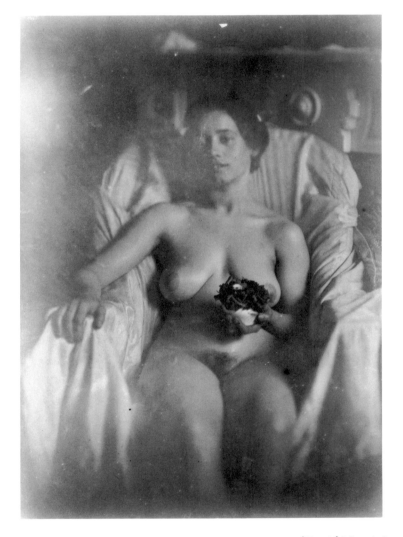

FRANK EUGENE. *Untitled.* Circa 1913. Courtesy of David Mancini Gallery, Philadelphia, Pennsylvania.

Nude photography during the last two decades of the century was different. Whereas most of nineteenth-century erotic imagery can be viewed in terms of direct objectivity and as a matrix for knowledge, *fin-de-siècle* Pictorialist photography is notable for its overt subjectivity and poetics. The reasons for the change were aesthetic as well as technical. Pictorialist photographers attempted to address the limitations of their art. Many, like Robert Demachy, René Le Bègue and Frank Eugene, hand-worked their prints, valued softer definitions of form and delighted in literary associations while playing down the non-artful objectivity of the camera image. By about 1900, a sometimes complicated, personal symbolism of suggestion and obsession infused the allegories and compositions of the nude. Symbolist and Synthetist iconographies of adolescence in thorn groves, *La belle dame sans merci*, madonnas, incarnations of purity and vampires find their depiction in the art and photography of the period. The writings of Oscar Wilde and J. K. Huysmans are, in their treatment of sexuality, distinctly different from the journalistic reportage of De Sade or the contemporary but retrogressive *My Secret Life.* Burne-Jones' *The Briar Wood* of 1884-1890 does not suggest the same order of erotic contemplation as would an Ingres odalisque of the 1810s, nor does the violent and contorted sensuality disporting across Rodin's *Gates of Hell* (1880-1917) compare with the joyous celebration of the sensate in *La Danse* of 1865 by Carpeaux. Sensitive to the same culturally popular themes and attitudes, Pictorialist photographers enjoined photography to the new art. Steichen effused the nude in a softened, nearly liquescent ambience—an atmosphere of nonpalpability and moody aestheticism. For most of his career, Clarence H. White photographed his obsessive concern with women, an inner vision of femininity seen playing domestic games, frolicking in apple orchards and very often nude, posed with otherworldly crystal orbs or funereal symbols of skulls and lilies. Spectral brides, vampires and gargoyles are prevalent in the work of Gertrude Käsebier, as are Sicilian boys embodying an hermetic antique in the photographs of Baron von Gloeden. These images were clearly as much fictive imaginings as the images by Muybridge were data for science.

THE various modalities of photography—the naturalistic and the symbolic, the objectifying and the literary, the presentational and the interpretive, the iconic and the narrative—are not strictly obedient to chronol-

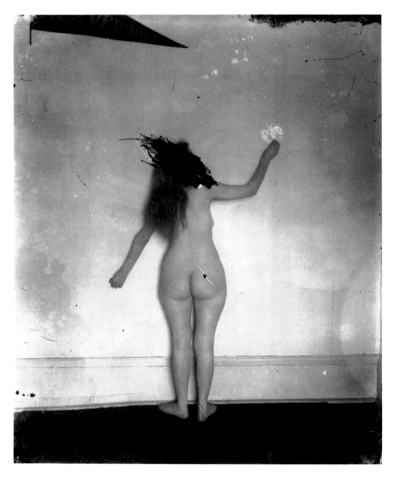

E. J. BELLOCQ. *Untitled.* Circa 1913. Courtesy of Lee Friedlander.

ogy. Throughout the twentieth century, a confusion of styles, often interrelated and overlapping, informed photographic erotics. The more traditional value of the camera to record mere matter and fact has been an equally active stylistic imperative as the suggesting of High Art erotics of the morbid and the dream. Brassaï's fascination with publically flaunted sexuality in cabarets was closely connected with the documentary style of the disengaged observer, the *flâneur* (one who "objectively" recorded the appearance of his or her world). E. J. Bellocq, like Brassaï, was also fascinated with the prostitute type. But Bellocq's portraits of the women in the New Orleans red light district of around 1912 somewhat begged the question of photography's capacity for detached reportage. These portraits, of both nude and clothed prostitutes, are closer in feeling to the non-nude portraits by Lewis Carroll in the 1860s than to any similar image by Brassaï. There is a clear sense of intimate, friendly rapport between the model and the artist, of playing a secret yet innocent game before the camera as though flirting with the illicit. The game played is a matter of coyly acting out with the prosaic finery of the domestically commonplace, with little regard to the "artistic" requirements of suitable decor or with in-situ realism. The viewer is drawn into the game and compelled to respond to it. Instead of controlling the objectified figure within a fantasy, the spectator participates with the self-conscious acting out, and enters into complicity with the private fantasy of the artist and model. The model's compliance is active and not, essentially, passive to either photographer or viewer; the viewer's fantasy reading of the erotic meaning is therefore moderated.

Formally abstracted photographs of the nude also curtail erotics. Distortions, photomontage, extensive solarization and negative printing address the eye directly and only then, perhaps, the erotic imagination. A veristic likeness and a concern for realistic analogues are customarily more effective as the raw material for evocative fantasy. It could be a matter of recording a satisfactory amount of accessible visual information as a stage on which the sexual mentalization can occur. Francis Bruguière's theatrical and expressionistic caprices of the 1920s and Moholy-Nagy's exercises in the grammar of photography defy an immediate erotic engagement with the image. The symbolic function, that aestheticizing of the palpably physical, common to erotic imagery, is then subordinated in these works to the overwhelming formalistic expression of the artist. André Kertész's resinous distortions are not especially naturalistic, but their formal effects, the aberrant deformations and perspectives, seem integrally aligned to the nude. The adaptation of the formal features is so specific to the photographer's image of the nude that the photograph is not simply erotic or formalistic but about the very process of erotic visualization and the absolute control of the mannequin it entails.

Most, if not all, modern erotic photography is a response to one of either two approaches to the nude figure: the iconic or the narrative. The iconic image is the presentation of a usually singular figure in which

174

the photograph's erotic meaning is located. The erotic sense resides in the figure alone, its implied sexuality and its represented physicality. The figure's look—the inaction of its frozen gestures and glance and the visual feel of the flesh—constitute a hieratic sign signifying eroticism; the figure is erotic. After Pictorialism, which was fundamentally narrative at heart, there was a rediscovery of the more classic mode of the "straight," unaltered photographic image and a redefinition of photography's original mandate—to record material nature—for this century. A great number of painters turned after World War I from the various forms of Cubism and Expressionism to either a figural classicism, like Picasso, or a heightened realism, like Otto Dix and George Grosz. Similarly, photographers, disillusioned with the romanticism of Pictorialism or mistrustful of abstraction, opted for the inherently photographic qualities of clarity, directness and, most importantly, iconic presentation. To be sure, any move toward straight photography was in large part due to the prewar example of Alfred Stieglitz who, along with others, stressed that the primary role of photography was to record nature in a positivistic manner, a naturalistic manner, but one that also implied an almost Joycean faith in epiphanous evocation. The poetics of meaning, for Stieglitz, was to be found in the quotidian, the everyday where a detail or fragment perceived by chance could be charged with symbolic import and reveal a larger truth.

In 1927, Edward Weston wrote that the *"simplified forms I search for in the nude body are not easy to find, nor record when I do find them. There is that element of chance in the body assuming an important movement. . . ."*[16] Weston, probably more than any other modern photographer in America, understood the basic eroticism and sensuousness of nature. His eroticism was also fundamentally an erotics of iconic inaction. The art critic Lucy Lippard described this variety of eroticism as it pertains to Minimal Art.

The rhythms of erotic experience can be a languorous sensuality. . . . The cool sensibility that approves understatement, detachment, the anticlimactic in art, tends to approach the erotic nonromantically, even non-objectively.[17]

For Weston, a machine part, a factory, and most especially more natural artifacts like seashells and vegetables are potentially as sensuous as the human form. Weston overly denied that his photographs of shells were erotic, only admitting they had a *"sensuous quality"* that combined the *"physical and the spiritual."*[18] Yet his friend, Tina Modotti, seemed more insightful when she wrote:

I cannot look at them long without feeling exceedingly perturbed, they disturb me not only mentally but physically. There is something so pure and at the same time so perverse about them. They contain both the innocence of natural things and the morbidity of a sophisticated, distorted mind. . . . They are mystical and erotic.[19]

Furthermore, Weston knew exactly that he was involved with the mechanics of the erotic. *"I see more than a housewife who picks commonplace peppers for stuffing,"* he exclaimed in 1931, *"so I have in some way violated these poor peppers!"*[20] In these photographs, as in his nudes, Weston isolated the object, presented it without a context, chose the most salient angle or detail, determined its surface actuality with a lighting that is nearly succulent and invested the object's entire meaning in its very appearance. These qualities are not unique to Weston's photography, but his nudes are sublime perfections of a detached eroticism. No reading or interpretation is required of them, they are non-narrative, their "languorous sensuality" speaks to the mind through the physical look of the nude.

Despite the impact of abstract formalism, Stieglitz's theosophical equivalences and the precisionism of twenties realism, the more narrative mode of Pictorialist photography, based on an emotionally romantic and literary attitude, has never been absent in modern photography. In fact, during the Depression era, there seems to have been a resurgence of interest in more conservative imagery, emphasizing storytelling and the "artful," decorative effect. The formal vocabularies of Constructivism, on the one hand, and of Art Deco advertising, on the other, were blended into a new decorative pictorialism and applied like a veneer onto the modern nude. Photographers, like Martin Munkacsi and František Drtikol, well understood the

175

dynamics of the diagonal or off-centered composition and frequently combined coy histrionics with highly suggestive accessories and shadows. Others played up the theatrics of vaudeville and the exotic dance, while some, like Paul Outerbridge, capitalized on the surrealist chic of the period—most especially the surreal macabre.

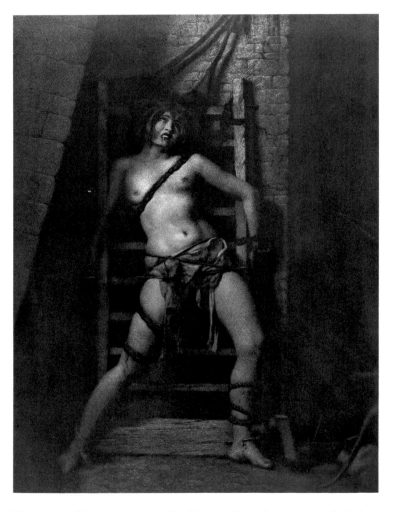

WILLIAM MORTENSEN. *The Heretic,* from *Monsters and Madonnas.* 1936. Collection of the International Museum of Photography at George Eastman House, Rochester, New York.

The grossly literary also reached an apex of popularity during the 1930s, most notably in the campy, history of surgery fictions by Lejaren à Hillers and the Sadean expositions of William Mortensen. Hillers' illustrations for pharmaceutical advertisements, done between 1927 and 1938, pictured fully clothed and

mostly male doctors ministering to the needs of voluptuously naked female patients. Subtlety and relevancy were not too terribly valued; the story was, on one level, simply the excuse for a sexist vision of the nude. Mortensen's imagery is similarly sexist and replete with violence, sado-masochism and the grotesque, while his writings represent an attempt at an art theory of such extremist erotics.

> *Persons who would be made acutely ill at seeing a dog run over in the street may quite sincerely enjoy contemplating the most brutal themes in the medium of the grotesque. . . . A piece of grotesque art may appeal, in a manner utterly refined and quintessential. . . .*[21]

Disinterring the Symbolist passions of the 1880s and 1890s, Mortensen carefully constructed and photographed such tableaux as *The Heretic* (also known as *The Spider Torture*), *Salomé, The Vampire* and *Preparation for the Sabbath*. These images were the complement to his more restrained compositions like *Youth* and *Frou-Frou,* but they were also a solution to an artistic problem. He explained:

> *Boredom, with the prosaic material of the everyday world, with the smug limitations of his medium, leads the artist to seek new and more expressive forms. Often this search brings him to the grotesque. The photographer bored to distraction by the banalities of realism and the imperious demands of the Machine, should find grateful release in the exaggerations of grotesque art.*[22]

This position is completely antipodal to that of Weston, who saw the camera as an extension of his vision and nature the most telling material for the artist. For Mortensen, realism was banal and the camera inhibited the photographer's obsessive vision.

EROTIC nude photography had, until World War II, operated at worst within the purview of the salacious and illicit and at best as a primarily private artistic expression and therefore culturally validated as art, pure and simple. After the war, however, a new public guise for nudity was established, in part due to chang-

ing permissions and in part as an evolution of the pin-up syndrome of the forties. Whether the air-brushed ideal types by Vargas or Gil Elvgren or the "Hollywood" glossies of Grable and Hayworth, the iconic and for the most part clothed pin-up functioned as an allowed, quasi-public titillation. But what was during the war years a droll flirtation with an implied sexuality became in the fifties a matter of divesting the pin-up of its costume and rendering its sexuality overt. The nude went public in a manner never seen before: it was mass produced, flaunted as a societal emblem and, like an emblem, its meaning became complex and protean. It was no longer the ideal measure of art whose use was legitimized and made appropriate by the artist; it had become a public vernacular with often little pretense at art. The esoteric became exoteric.

With publications like *Playboy* and, later in the sixties, *Vogue* and *Harper's Bazaar*, a great deal of what photographers had fashioned as discrete works of art was transposed into a commercially limitless arena. Furthermore, reproduction techniques brought a degree of quality color printing to the nude that raised it above the coarse, black and white syntax of the surreptitious "dirty magazine." The Playmate's eroticism was respectable and completely iconic. She was, as was frequently pointed out at the time, the "girl next door" fantasy, to be looked at but never touched. Like Psyche and other *fin-de-siècle* symbols of purity, her sexuality was clean, chaste, virginal and nearly immaterial; there was never a sign of untoward skin textures or unseemly hair. Similarly, photographs by Hiro, Avedon and Penn in European and American fashion magazines presented mannequins which not only enchanted with their perfect display of luxurious costumes, but toyed with the viewer in a stilled simulacrum of the striptease. Barthes defined the European striptease as a disclosure of an idea.

There will therefore be in striptease a whole series of coverings placed upon the body of the woman . . . establishing the woman right from the start as an object in disguise. The end of the striptease is then no longer to drag into the light a hidden depth, but to signify, through the shedding of an incongruous

and artificial clothing, nakedness as a natural vesture of woman, which amounts in the end to a regaining of a perfectly chaste state of the flesh.[23]

Like the striptease entertainer, the fashion model is an objectification of an ideal mental image, an aestheticizing of the physical for the delectation of the mind; like the Playmate, the mannequin is to be seen as an image and appropriated by the mind but never materially made real.

By the late sixties and early seventies, the pages of international fashion magazines became the principal forum of the erotic chic and the openly provocative. The unabashed public display of bodily "perfection" assumed additional symbolic functions in both editorial and advertising photographs. Symbolism, from phallic cigars to bleeding lips, was allied to flagrant exhibitionism, a vehicle for the voyeur's polyperverse sensibilities. Simple eroticism was joined with aggressiveness, blatant domination and masochistic acting-out, all in the service of marketing gasoline or toothpaste. The pure nude was in part replaced by a narrative, situational image that located the nude within an enactment of the questionable and the elegantly paranormal. Helmut Newton's implications of bloody homicides and suggested pathologies and Deborah Turbeville's visions of catatonic sexuality in unexpected architectures are completely erotic, camera-realized fantasies of the nearly dysfunctional. If the nineteenth century was a society of "blatant and fragmented perversion," the twentieth has certainly made this sexual mosaic that much more shamelessly open.

THE entire history of nude photography is now available to the contemporary photographer through an unprecedented interest in the medium, its styles and its traditions. The great and nearly great achievements of erotic and nude photography—whether done in the service of personal expression, of science or marketing—constitute a rich source of invention as well as at times an overwhelming heritage. The suffusion of the erotic photograph, its mass distribution in the art and commercial arenas, from exhibitions to the monumental signs decorating the cityscapes, poses

177

certain issues for the contemporary art photographer. First, in no way can he or she not respond to the historic or public nude either in terms of its formal and thematic language or in terms of its societal acceptance. And there is the issue of just how sexuality connects with actively politicized stances, both individually and culturally. Finally, there is the question of a contemporary personalized expression in the face of extensive public proliferation of the nude image. What are the necessarily meaningful choices left for an individual statement regarding this subject? One option seems to be toward the greater personal domestication of nudity; friends, lovers and family are now more than ever the photographer's models instead of the disinterested mannequin. In photographs as widely dissimilar as those by Harry Callahan, Emmet Gowin, David Hockney and Robert Mapplethorpe a sensitive and highly humanistic confrontation with a relational privacy is at work; an unmasking of intimacy. A second choice, and one seemingly more prevalent, is to fashion a strictly private poetics of fiction with an obscure iconography investing the image, a literary image rich with secluded fantasies and histories. Duane Michals' and Les Krims' patently fictionalized and psychologically charged theaters of the estranged are photographic metaphors to dream states and cosmic psychodramas. Any discrete and specific meaning to Robert Heinecken's pornographic vocabulary or to Eikoh Hosoe's insulated memories in his *Simon* series is not really to the point; the secret, melancholic realms they portray will hardly be accessible, although they will be sensed.

IN 1928, Georges Bataille described a hidden and very particular area of the mind,

> *a profound region of my mind, where certain images coincide, the elementary ones, the* completely *obscene one, i.e., the most scandalous, precisely those on which the conscious floats indefinitely, unable to endure them without an explosion or aberration.*[24]

The photography of pathologically intense sensations and ideas, those images signifying for us the scandal of

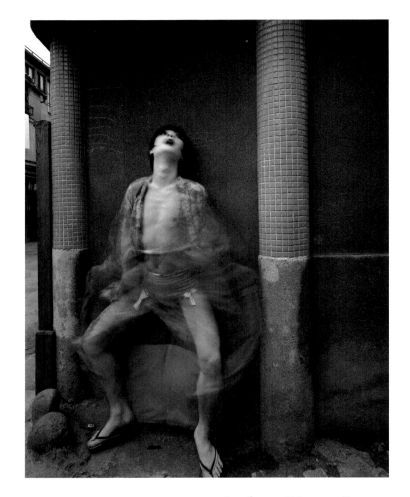

EIKOH HOSOE. *Simon: A Private Landscape #6.* 1971. Courtesy of the photographer.

our own proximity to this realm and testifying to our identity with this otherness, are the most poignant and troubling erotic images. More than just reasserting our safe distance from what they represent, such photographs affirm at once the possibilities of the physical and the cerebral. To objectify the extremes of the erotic in photography brings with it the contemplation of what might be but for chance or fear. It also glorifies what is, both as itself, distinct from everything else, and in itself for what it can provoke. Erotic photographs, all erotic photographs, accomplish this function to some degree, but those pictures made merely to shock or dismay, those images which generate a reaction by their obvious and irrelevant defiance of expectations are not at issue here. Rather, it is a question of those images, like Lucas Samaras' violently onanistic "autopolaroids" and other self-por-

178

traiture of alternative selves, which force a real interrogation about the self and the other, about the "you" and the "I." By their density of meaning and their absolute alien quality, these are images that compel the dichotomies of the erotic and nonerotic, sanity and insanity, safety and risk, the very limits of the possible and the void of negation. The realm these images exist in is similar to that place of *"awesome silence"* Yukio Mishima located as the setting for Hosoe's unpeeling of Mishima's persona in *Killed by Roses, "where Death and Eros frolicked wantonly in broad daylight."*[25] It is also a realm where an image of a post-autopsy female, found as if in graceful dance and photographed by Jeffrey Silverthorne, is silently manifest of transcendent eroticism. Such images bring to mind the essence of the medieval *memento mori* which served to remind the viewer what he or she was still and not at all.

Validation of emotion and life is the essence of all erotic imagery; like eroticism itself, the erotic photograph attests to life and the living and, by so doing, *"exiles death."*[26] The image of the nude is a celebration of the human, its look and palpable nature. It is also, at the same time, a consecration of the mind's capacity for emotional and intellectual delectation. The erotic photograph is a document of human pleasure; it is as well the extolment of the idea of that pleasure. It is an iconic presentation or a narrative depiction of an erotic object or fantasy, but it is also the immediate cause of an erotic inner imaging. It is the objectification of desire, a mental catalyst affirming the sexual and the aesthetic. It is the visual savoring of an idea, "kneaded by fingers which are the eyes."

ROBERT SOBIESZEK

NOTES

1. William Henry Fox Talbot, *The Pencil of Nature*, London, 1844, unpaginated.

2. Cited in M. H. Abrams, *The Mirror and the Lamp: Romantic Theory and the Critical Tradition*, New York, 1958, p. 57.

3. Cited in Francis Steegmuller (ed. and trans.), *Flaubert in Egypt: A Sensibility on Tour*, Boston, 1972, p. 11.

4. Kurt Vonnegut, Jr., *Slaughterhouse Five, or the Children's Crusade*, New York, 1971, pp. 40–41.

5. Cf. Robert Rosenblum, "The Origin of Painting: A Problem in the Iconography of Romantic Classicism," *Art Bulletin*, XXXIX, 4 (December 1957), pp. 279–290.

6. Advertisement for Mascher's stereo case, *Scientific American*, 28 May, 1853, unpaginated.

7. Kenneth Clark, *The Nude: A Study in Ideal Form*, New York, 1956, especially Chapter I.

8. Cited in Georges Bataille, *L'Erotisme* (n.d.), uncredited trans. in *Death and Sensuality: A Study of Eroticism and the Taboo*, New York, 1962, p. 11.

9. Georges Bataille, *Death and Sensuality*, pp. 16–7.

10. Cf. R. Barthes, "Shock-Photos," trans. by R. Howard in *The Eiffel Tower and Other Mythologies*, New York, 1979, p. 73.

11. Alain Robbe-Grillet, "A Voyeur in the Labyrinth," *Evergreen Review*, 43 (October 1966), pp. 47ff.

12. Susan Sontag, *On Photography*, New York, 1977, p. 4.

13. Kobo Abé. *The Box Man*, trans. by E. D. Saunders, New York, 1974, p. 48.

14. A. Tardieu, *Etude médico-légale sur les attentats aux mœurs*, Paris, 1857, p. 114; cited in M. Foucault, *La Volonté de savoir* (1976), trans. by R.

Hurley in *The History of Sexuality, I., An Introduction*, New York, 1978, p. 24.

15. M. Foucault, *The History of Sexuality*, p. 47.

16. N. Newhall (ed.), *The Daybooks of Edward Weston, Volume II, California*, New York, 1966, p. 10.

17. Lucy Lippard, "Eros Presumptive," in Gregory Battcock, *Minimal Art: A Critical Anthology*, New York, 1968, p. 217.

18. *The Daybooks of Edward Weston, Volume II*, p. 32.

19. Cited in *The Daybooks of Edward Weston, Volume II*, p. 31.

20. *The Daybooks of Edward Weston, Volume II*, p. 231.

21. W. Mortensen, *Monsters and Madonnas: A Book of Methods*, San Francisco, 1936, unpaginated.

22. W. Mortensen, *Monsters and Madonnas*, unpaginated.

23. R. Barthes, "Striptease," trans. by A. Lavers in *Mythologies*, London, 1972, pp. 84–85.

24. Georges Bataille, *Histoire de l'Oeil* (1928), trans. by J. Neugroschel in *Story of the Eye by Lord Auch*, New York, 1977, p. 105; cf. André Breton, *Second Manifeste du Surréalisme* (1930): "Everything leads us to believe that there exists a spot in the mind from which life and death, the real and the imaginary, the past and the future, the high and the low, the communicable and the incommunicable will cease to appear contradictory," cited and trans. in P. Walberg, *Surrealism*, London, p. 43.

25. Yukio Mishima, "Preface," in E. Hosoe and Yukio Mishima, *Killed by Roses*, Tokyo, 1963, unpaginated.

26. M. Foucault, *The History of Sexuality*, p. 58; cf. also, Georges Bataille, *Death and Sensuality*, p. 11.

NUDE
IN A SOCIAL LANDSCAPE

BEN MADDOW

*"T'our bodies turn we then,
That so,
 Weak men on love reveal'd may look;
 Love's mysteries in souls do grow,
 But yet the body is his book."*

JOHN DONNE, *The Ecstasy*

ONE of the loveliest photographs ever made, in the brief history of the art, is Clarence H. White's double nude, mother and child, at a partly curtained window (*Plate* 34). He lived in Ohio till he was thirty-five, and the best of his work invokes the small town where he lived, sweet with lilacs and spiced with domestic melancholy; for him, life and art were an extension of one another.

The real world, for that matter, is inextricably embedded in every photograph ever taken. This is particularly true of the nude; such photographs carry with them the elaborate furniture of the time, the morals, the conceptions and misconceptions, not only of the society where a photograph was made—but of the society (which may be a hundred years later) where it is now seen. If we examine an early daguerreotype, say the stereo of the woman on the striped bed (*Plate* 6), we see far more than a curved area in a rectangular space. We sense the real woman, and have an insight into her actual or pretended character, and through her feel the invisible and complex aura of her time and place. It's interesting, from this point of view, to look at a photograph (*Plate* 31) attributed to the painter Edgar Degas, who was born in the decade of the invention of photography and lived through one of its most flourishing periods. The model is posed in a studio, furnished with a tub, a bed, a towel, and sheets; and she is positioned so that her body is twisted and contorted—almost as if by force—over a huge bolster on the bed. No model could hold this position for very long. One arm is bent under her by the torsion and she kneels on one foot with the other lifted. Degas made a subsequent painting which appears to have been copied with precise detail from that very photograph. The painting is animated by Degas' nervous pigments. The body has become a symbol for the voluptuous sensations of bathing and drying, of water and skin. But the photograph, too, has now become, because of our present sensitivity to such matters, a moving piece of art. It is no longer simply a study, like a preliminary charcoal; but because of something intrinsic to photography, the photographic image is something ruder, less disciplined, closer to what the Japanese call "the floating world" of daily experience. This is because the photograph contains, as no graphic work done by a finite hand can ever match, an inexhaustible connection to reality: in its infinity of detail, in its infinitesimal gradation of light into dark and back again—qualities that belong only to the unmatched subtlety of the world and to the photographs that are its projection onto a plane.

YET this real world and the photographs that correspond to it are altered by the habits and prejudices of the brain behind our eyes. In western society of the nineteenth and twentieth centuries, that is today, in Europe and America, there are three main views of the naked human body. To describe them properly we must also look at literature and painting.

What could better give us the essence of the early nineteenth-century Romantic attitude to the body—which equates beauty of the figure and the soul—than this passage from Goethe's secretary, J. P. Eckermann, written just after the poet's death in 1832?

> *. . . The body lay naked, only wrapped in a white sheet; large pieces of ice had been placed near it, to keep it fresh as long as possible. Frederic drew aside the sheet, and I was astonished at the divine magnificence of the limbs. The breast was powerful, broad, and arched; the arms and thighs were full, and softly muscular; the feet were elegant, and the most perfect shape; nowhere, on the whole body, was there a trace either of fat or of leanness and decay. A perfect man lay in great beauty before me; and the rapture which the sight caused made me forget for a moment that the immortal spirit had left such an abode.*

Men saw with such specificity of detail—and could describe that sight—long before they could put it into a photographic print. They longed to record the image forever. In that sense, photography—like other inventions, for example the airplane and the sound recording—is the embodiment of a common daydream. Alfred Stieglitz's cumulative portrait of Georgia O'Keeffe preserves her naked, close, and warm forever; it shares this quality with a Cranach nude, or the Marvell poem to his reluctant mistress—the wish to stop the melancholy advance of time and oblivion.

Many photographs in this collection have this moving and romantic tone. But there are two more usual and deceptive ways to describe the body: one is to laud nakedness as ideal; the other to despise it as the landscape of evil.

N U D E is what we are; yet we are unfamiliar strangers, even to ourselves. After all, we spend most of our waking time hidden in the woven shell of our clothes. Naked briefly as we dress or undress, or bend ourselves in the bath; from a high angle in a morning shower, or in the mirror of our privacy, we come to see our bodies, if we look at all, with a sense of tender shock.

Nudity uncoils our emotions: good and bad, ugly and beautiful; and we invent illusions to soften the truth of our own feelings. An early and still popular belief is that nakedness, or even worse, the depiction of nudity in art, is somehow wicked and shameful. This was never a common tenet before Christianity. There are mild hints in the Old Testament, but it is never a doctrine, nor is it taught in the parables of the Four Gospels. Only in the letters of Saint Paul do we find the stubborn seeds of this dogma.

The shame of the nude is made equal to the shame of sex; and this equivalence is derived from the social lie that women were by nature a lower form of humanity. Saint Paul wrote to one of his congregations:

Let the woman learn in silence with all subjection. But I suffer not a woman to teach, nor to usurp authority over the man, but to be in silence. For Adam was first formed, then Eve. And Adam was

not deceived, but the woman being deceived was in the transgression. Notwithstanding she shall be saved in childbearing...

Yet in the great Flemish triptychs of the fifteenth-century painter Roger van der Weyden, nakedness appears quite openly: the throng of the damned screaming in hell are nude, but even the elected few mounting the stairs of paradise are quite naked, too; and both damned and saved, whether souls without bodies or bodies without souls, are painted voluptuously; while all above them the saints are wearing voluminous cloaks.

When Michelangelo brought forth *David*, and the nude giant was being transported to its pedestal, it was stoned by the young street gangs of Father Savonarola, that martyr and saint of the Florentine merchant republic. The human body as beautiful in itself was an idea proscribed in art—but only for the general public. Albrecht Dürer's etching, *The Witches* (four naked women, each with a different headdress to show how the social classes were coarsely mingled in a coven of witches, with the devil peering up at them from a hatch of flames) pretends to be rooted in the Christian attitude—that between a naked woman's legs lies the ancient furrow of sin. But this work, unlike the *David*, was not made for public display, but for sale to a rich collector; its moral lesson was a convenient hypocrisy.

The visual pleasures of sex were never abolished but were usually locked into private cabinets. The subjects were religious, but they would show Eve and Adam in the full glory of sensual nudity. For centuries, the wealthy noble, merchant, or priest could commission and buy the nude in art. Two of Titian's serene and buttery Venuses, painted in the sixteenth century and using for a model a famous courtesan of the time, were made especially for the Emperor Charles V. In his private gallery, Frederick II of Germany kept a painting of Bathsheba naked at her marble pool. This interesting Biblical subject was common in all of Europe; such painted nudes were commissioned, bought, enjoyed, and inherited—privately.

There were no public museums until the revolutions, industrial and political, of the late eighteenth and early nineteenth centuries. Public museums,

where the cotton mill operative or coal miner or tenant farmer might take his family on a holiday afternoon, simply did not exist—until the Louvre was opened in 1793; the great Berlin Museum in 1830; the National Gallery in London in the 1830s; the Victoria and Albert in 1852; and the famous Museum of Fine Arts in Boston not until 1876, six years after the inauguration of the Metropolitan Museum in New York City.

It's striking that photography and free museums were more or less concurrently born and nurtured but the coincidence is not mysterious; their common cause was the democratic ideal. Photography was initially a means of bringing art to masses of people. It was invented by Niepce as a kind of easy lithograph; it was not available to everybody, of course, but certainly to the increasing middle-class merchants and skilled workers, clerks and bankers, farmers and petty officials. Free public museums and the avalanche of photography are coincident because they are two products of the same social history.

But with the gradual access to power of these middle classes, their strict morality greatly discouraged the nude in literature, particularly in England and America. The naked body—sometimes censored with the Biblical leaf—was allowed in public museums, disguised as allegory or mythology. Photographs were a far different case. They were considered a craft not an art. They were displayed, throughout most of the nineteenth century, not in the formality of museums, with their hushed air and stone corridors, but in the popular noise and confusion of the great nineteenth-century expositions. It would have been unthinkable to display photographic studies of the naked human body to millions of visitors at such democratic celebrations—precisely because of their unique power, which is to some degree erotic, and which a narrow Christianity sought to restrain.

BUT for at least five thousand years, there was an opposite point of view. It was minor and heretical but equally logical and equally odd. This view held that nakedness was the very talisman of all virtue and health. The origin of this peculiar idea was in the longing of civilized, agricultural man for the Eden where food was as free as air, and man was unclothed, hence natural and therefore virtuous: all fallacious but plausible approaches. It was held to be true of a Golden Age, either long ago or across the sea, a paradise in the primitive forest outside the walled village, where naked, simple man lived before he was corrupted. In the ancient Babylonian epic poem *Gilgamesh*, the weary, sated king sends for this naked virtuous man of nature. When, out of his native purity, he refuses, the king lures him to the palace with the charms of his chief concubine; the king wrestles with Enkidu and thereby becomes his friend. But the end of this pure savage is corruption and death. The great power of this myth of the naked, wild and natural man persists through centuries of different folklore—the hairy man living in the woods; the pure and holy hermit, naked of wordly goods; the sadhu clothed only in a pattern of ashes. The nudist camps have a history that goes back at least to the Adamites—the naked, sensual heretics of the fifteenth century, whose propagandist was the painter Hieronymus Bosch, with his *Paradise* of naked men and women in the purifying pool. Yet it is rare to find, except in our fantasy, the naked savage of civilized longing. Tribal people decorate their bodies with tribal art: they wear face and body paint, penis sheaths, aprons, huge lip, nose, and ear lobe ornaments, and construct an architecture of elaborate mud and grease with their hair. The nude as pure is perhaps nostalgia for our naked childhood—as if that were wholly innocent either.

The idea that the nude was a form of natural purity is thus as old, and as persistent, as the notion that nude is the seductive doorway to hell. Both are historic illusions and, like other beliefs, could be held by the same society, even when contradictory. England, France, and the United States are each different cases in point. As their societies changed, so did their view of the naked body.

The earliest sonnets of Shakespeare describe Venus as "*teaching the sheets a whiter hue than white*"; and his near contemporary, John Donne, wrote twenty-one elegies on the subject of love. It is a young man's poetry; and the mistress he describes seldom wears any clothes at all:

*License my roving hands and let them go
Behind, before, above, between, below.
O my America! my new-found-land!
. . . Full nakedness, all joys are due to thee!
As souls unbodied, bodies uncloth'd must be
To taste whole joys . . .
. . . Cast all, yea, this white linen hence;
Here's no penance, much less innocence.*

How is it possible to publish such poetry at all—under the prohibition of a church whose power might be challenged, but never its dogmas? The fact was that such poems were read by only that minute fraction of Englishmen who could read or could hire somebody to read to them; and this audience was sophisticated, wealthy, and noble.

This poetic friendship toward the body was to change—superficially anyway—when pious businessmen and artisans rose against corruption in church and court; this was England's first and only revolution, which cut off the feeble head of their king. It was a brief, moral, and tryannical time and therefore not fertile to poetry of the human and the sensual. Cromwell died, and Charles II put on the jeweled crown in 1660; but the mold had hardened; England would never retreat from the Ironside morality. It is amazing, and somewhat troubling, that the naked body should not appear in English graphic art until well into the eighteenth century, and then only in the caricatures of Rowlandson and Hogarth; and the clever obscenities, complete with high coiffure, of the Swiss immigrant Fuseli. In these the naked body is drawn as if it were the costume of the nasty and the corrupt. Although this was the view held by the majority of Englishmen, there was also the minority illusion that the body was the temple of natural virtue.

Blake, a contemporary and friend of Fuseli, drew nudes by the score, but they were so generalized by his peculiar vision, that, although they are without clothes, one scarcely recognizes them as human. But his philosophy was utopian: factories and clothes he held to be equally unhealthy:

The flush of health is flesh exposed to the open air, nourished by the spirits of forests and floods; in that ancient happy period which history has recorded,

cannot be found the sickly daubs of Titian or Rubens . . . Where will the copier of nature, as it now is, find a civilized man who has been accustomed to go naked? . . . In Mr. B————'s Britons the blood is seen to circulate in their limbs; he defies composition in coloring.

These are Blake's words in praise of himself.

But he stood neck-deep against the icy current of British morality—composed equally of public virtue and private vice. British art was censored most severely by the artist himself. J. M. W. Turner, famous for his seascapes, drew not only single nudes from life, and kept them secret; but also drew sexual couplings that, as those of Rembrandt, are hot from the furnace of personal experience. Even now, these are still available only to scholars at the British Museum. The invention by the Englishman William Fox Talbot, sometime in 1834, of a new process (that, unlike the daguerreotype, would allow multiple prints to be made from a single negative) gave the photographer technical, but not artistic freedom. Talbot photographed no nudes, nor did the far greater Scottish artists, David Octavius Hill and Robert Adamson; nor did English painters attempt the frank nude until late in the century.

The naked body was still exclusively connected with sex, and sex was plainly dangerous. Browning, that coarse poet of the mid-century, mid-Victorian England, which was the central age of the cruel and sentimental middle class, said no more than what was universally assumed: *"The naked life is gross till clothed upon . . ."* Words, then, were themselves a kind of clothing upon the powerful specificities of physical love. The nudes that were actually photographed were of a curiously restricted sort—they were children. This was the nude made respectable by the natural purity of those too recently born to be sinful. Wordsworth, in 1803, only expressed what every Englishman believed:

*Not in entire forgetfulness,
And not in utter nakedness,
But trailing clouds of glory do we come
From God, Who is our home:
Heaven lies about us in our infancy.*

Lewis Carroll piously agreed:

> I don't think anybody who has only seen children [in the presence of their elders] has any idea of the loveliness of a child's mind. I have been largely privileged in tête-a-tête intercourse with children. It is very healthy and helpful to one's own spiritual life: and humbling too, to come in contact with souls so much purer and nearer to God, than one feels oneself to be.

Carroll made a number of nude photographs of children, but these were largely destroyed by his nephew; the ones that survive are those that Carroll sent to an artist to be tinted and mounted over a painted landscape; they are amazingly ugly and saccharine. His contemporary, the very great camerawoman Julia Margaret Cameron, succumbed to the same taste; her studies of nude children are sentimental, too. Carroll's friend O. J. Rejlander, a frankly commercial workman, specialized in juvenile nudes, but their poses were for private sale and therefore plainly provocative. The provincial portraitist Frank Sutcliffe did far more interesting work; and yet his photographs of the nude were always young boys—faced away and looking out to sea. Yet for even this much revelation, exhibited in shop windows, Sutcliffe was anathematized by the local clergy for tending, as he reported, "to the corruption of the young of the other sex."

English intellectual life, then as now, was close, even claustrophobic; and among Carroll's numerous acquaintances were the painters who declared their allegiance only to the unsophisticated painting before Raphael. Although their nudes were among the first publicly shown, they were permitted on the pretext that they simply revealed the degeneracy of the old Roman Empire. Those fine, graceful, multiple arabesques of American nudes, photographed by the English emigrant Eadweard Muybridge, were much admired by these British artists; but it was late in their careers, 1887, and in any case, his work broke no barriers for English photography.

One remarkable exception was George Bernard Shaw. He was obsessed, among other things, by a cheerful combination of vegetarianism, socialism and nudity. He wrote in October 1901:

> If a calculation were made of the subjects represented by the total superficial area of silver, platinum, gum, and tissue in the galleries, the result would probably be ten per cent, of humanity, thirty percent, of background, and sixty per cent, of clothes. In the New Gallery there is, amid acres of millinery and tailoring, just one small study of a whole woman . . . True, the camera will not build up the human figure into a monumental fiction as Michael Angelo did, or coil it cunningly into a decorative one, as Burne-Jones did. But it will draw it as it is, in the clearest purity or the softest mystery, as no draughtsman can or ever could. And by the seriousness of its veracity it will make the slightest lubricity intolerable. . . . Photography is so truthful—its subjects are so obviously realities and not idle fancies—that dignity is imposed on it as effectually as it is on a church congregation. Unfortunately, so is that false decency, rightly detested by artists, which teaches people to be ashamed of their bodies: and I am sorry to see that the photographic life-school still shirks the faces of its sitters, and thus gives them a disagreeable air of doing something they are ashamed of.

Five years after this review appeared, "Mr. Shaw was harshly ridiculed and sharply censured for permitting the exhibition in 1906 of a nude photograph of himself by [the American photographer] Alvin Langdon Coburn. . . ." And it was Coburn who noted that Shaw had said, "Though we have hundreds of photographs of Dickens and Wagner, we see nothing of them except their suits of clothes with their heads sticking out; and what is the use of that?" Unfortunately, truth doesn't always make good art, and Coburn's portrait of Shaw nude is simply rather silly.

The fact is that England, though poor in great artists, was rich in fine photographers, particularly in the last decades of the nineteenth century; but they had the manners of the middle-class among whom they lived. Men like P. H. Emerson and Frederick Evans did best with English countryside and the pillars and steps of English cathedrals. The starker, more pungent beauty of the nude was rarely attempted.

There could be no great photographs of the human body until the English Puritan pattern was shattered. It wasn't the War of 1914-18 that did it. In the last year of the war, the British magazine *Photogram* reproduced several nude studies, all second rate and veiled with coy titles like *The Frieze* or *The Bubble*; it's strange that both in England and America during the period 1895-1920 there often was, in a photograph of a nude, some round, glittering object—a glass sphere, a circular mirror, or the full moon; they were props borrowed from dance. Not the war itself, but post-war revulsion, the horror of a million British dead, cracked open the Victorian shell of clothes and manners. In the course of a change in British sexual morality, British art was freed from its stale conventions, and its literature altered forever.

D. H. Lawrence was one of the first and the boldest; yet even he had to sweeten his lesson with moral candy. Here is (in 1928) Lady Chatterley's gamekeeper speaking; he represents Shaw's healthy and natural man:

'Ay!' he said. 'You're right. It's that really. It's that all the way through. I knew it with the men. I had to be in touch with them, physically, and not go back on it. I had to be bodily aware of them and a bit tender to them, even if I put 'em through hell. It's a question of awareness, as Buddha said. But even he fought shy of the bodily awareness, and that natural physical tenderness, which is the best, even between men; in a proper manly way. Makes 'em really manly, not so monkeyish! Ah! it's tenderness, really; it's cunt-awareness. Sex is really only touch, the closest of all touch. And it's touch we're afraid of. We're only half-conscious, and half alive. We've got to come alive and aware. Especially the English have got to get into touch with one another a bit delicate and a bit tender. It's our crying need.'

It's this delicacy and this tenderness that we sense in the English nudes of the twentieth century. They are good qualities too; one feels them especially in the photographer Bill Brandt. All the optical experiments of his later nudes do not hide this soft appreciation. The eye of serious simplicity that photographed miners and servant maids and poets is able to see a naked woman with the same sweetness and truth. In the new English eye, she is neither wicked nor healthy; she simply follows the same powerful tradition that we have seen in Cranach or Titian or Rembrandt—of the frank nude as the most marvelous subject of any art.

THE daguerreotype was patented in France in 1839, and in the same decade photographs of the nude were already being made; and this because French culture instantly recognized the close and pleasurable relationships between the life-size world and its silver miniature. In the words of Delacroix (1850):

A daguerreotype is more than a tracing, it is the mirror of the object, certain details almost always neglected in drawings from nature, there—in the daguerreotype—characteristically take on a great importance, and thus bring the artist into a full understanding of the construction. . . . It is still only a reflection of the real, only a copy, in some ways false just because it is so exact.

Yet if we look carefully at the nudes posed by Delacroix himself in the studio of his friend, the retired lawyer Jean Durieu, we will see one of the disturbing virtues of the nude in photography: that it is not Man or Woman, but a particular man or woman; not a pose alone, but a portrait of the subject; not simply a record of the curves and volumes of the human body, but a direct insight into that singular, mortal person.

When we break our careless habit of giving no more than an instantaneous glance to photographs and allow ourselves to view a print for at least several minutes, to sink into its various wonders, we can define and intensify our vision of the photographed nude. We will certainly find that many anonymous photographs, especially the French daguerreotypes, wear pornography more like a costume or an affectation—they now give us a visual pleasure which is somehow deeper than the purpose for which they may have been made. These daguerreotypes, intended for the private pleasure of a collector, have now transcended commerce; and simply because they still exist have become saturated, not only with the infinite information of all subtle photographs, but with the

plain tragedy of death. Their bodies have perished, but their portraits have survived; their eyes still look at us.

Now the great number of such photographs would imply that nakedness was not a French taboo; but that is not quite accurate. The French revolutions and counterrevolutions from 1781 onward installed a more Puritan morality; though it did not have the stubborn conviction of the English, it was powerful enough to cover nudity in both art and letters. In 1850, the sale (though not the possession) of photographic nudes was punishable by fine and imprisonment; drawings and paintings were not so forbidden. These rules were not entirely stupid; they recognized the uncomfortable fact that photographs are, whether we like it or not, closer to the real world of the senses than marble, ink or paint.

And in the graphic arts, the nude appears as early as the fifteenth century, and is exalted in the miniatures of Jean Clouet. Antoine Watteau's early eighteenth century drawings (many were destroyed by him before he died) were even more explicit than his paintings. François Boucher painted erotic parables on commission, with the patron, for example, sprawled on the ground while his young mistress flies overhead on her high swing. And in the mid-eighteenth century, the work of Jean Honoré Fragonard, so delicately and softly drawn, depicted not only frank nudes but intercourse as well; and these scenes were sometimes rustic, sometimes aristocratic; and often, by the conventions of the day, both.

Note that the cult of nudity as the medicine of health was never particularly strong in France, although in 1749 Jean Jacques Rousseau won a prize for attacking civilization as corruptive of the natural goodness of man. The book was burned ceremonially in France and Switzerland; yet it had nothing to say about the sexual innocence or guilt of the nude. Rousseau himself was nervous about such questions; he confessed that when he was young, "*I could hardly believe that I was seeing at such close quarters that terrible animal, a woman.*"

Eroticism had been adding indelible color to French life for many centuries. It is to be found in the earliest French novels, like that classic of seduction, *Les Liaison Dangereuses* (1782): "*He cursed his clothes,*

which, he said, kept him at a distance from me." In *Splendeurs et Misères des Courtisanes* by Honoré de Balzac—in whom all the best and worst qualities of French fiction are interwoven, the bathetic and the truthful—the human body is drawn with sumptuous and morbid detail:

> *He was, certainly, insensible to the pretty, round breasts half-flattened against the knees and the delicious forms of a crouching Venus revealed beneath the black material of the skirt, so tensely was the dying woman coiled upon herself; the abandon of this head, which, seen from behind, displayed its white, supple, vulnerable nape, the beautiful shoulders of a nature boldly developed, did not move him. . . .*

In 1856, Flaubert published that beautiful novel of false romantic passion, that strange parallel to *Don Quixote*, in which the deluded person was a woman, Madame Bovary; and once again there is a passage whose enormous detail is not to be found in American and British fiction until the twentieth century:

> *Her heavy breathing dilated her thin nostrils and raised the fleshy corners of her lips, with their delicate shadow of dark down. Her twisted hair seemed to have been arranged by some artist skilled in corruption; it lay coiled in a heavy mass, carelessly shaped by the adulterous embraces that loosened it every day. Her voice now took on softer inflections and so did her body; even the folds of her dress and the arch of her foot gave off a kind of subtle, penetrating emanation. . . .*
>
> *She would eagerly throw off her clothes, pulling her thin corset string so violently that it hissed like a snake winding itself around her hips. After she had tiptoed barefoot to the door to make sure once again that it was locked, she would let all her clothes fall in a single movement; then, pale, silent and solemn, she would fling herself on his chest and a long tremor would run through her body. . . .*

Next year, though, both Flaubert and his novel were tried for offenses against morality and religion; but he and the book were both acquitted.

THE nude was photographed in France and in great numbers, and not solely for private collectors. Wonderful examples are to be found among the motion studies of Professor Etienne Jules Marey, done in 1882. Even better are a series of rather formal nudes done for the French army toward the very end of the nineteenth century, which were meant to study the physique of *le fantassin*—the foot soldier. In ordered postures, standing, kneeling, walking, marching, stretching, to show the bundles of muscle—there appears unbidden the squat, powerful, and shrewd character of the French peasant. The prints are examples of good, honest, sensitive craft. Here the function of the photographic nude was not to please, but to instruct. Marey was a scientist; the anonymous French military cameraman had no art in mind. He was simply doing what his officer had ordered. It is our aesthetic, right now, as we enter the last fraction of the twentieth century, that has revealed such photographs to be authentically beautiful. At the time they were made, they were simply documents.

They form an interesting contrast to the softer studies of the nude that appeared in such numbers in the same decade. The invention of the dry plate in 1885 made it technically possible to create prints that looked like drawings and etchings. The result, if not the intention, was to alter native truth and, with brush or chemical manipulation, soften the disturbing precision of detail and so bring a sentimental, popular, fuzzy salacity to the nude. Robert Demachy, a French photographer with the self-indulgent ideas of a rich amateur, actually said in innumerable lectures that no photograph could be considered a work of art unless it had been remolded by the hand of the artist. This was such a convincing fallacy that methods like his for altering the image in the darkroom became universal throughout the photographic world. Yet the results were not always bad. Demachy himself made several nudes that are very lovely; although it might be argued that the reality of any original negative is too strong to be wholly oiled away.

MEANWHILE, many thousands of nude photographs, labeled Etudes Artistiques, for example, could be bought on the streets of Paris or Marseilles or even Lyon. These nudes were not made for artists or collectors, but were mass-produced for tourists, both foreign and French; and sometimes they were taken only as advertisements for brothels. One must confess that there is little except the weary charm of camp in the popular patriotic nudes proclaiming the Triumph of the Republic, or the birth, by breech presentation, of a little woman from a giant egg.

After the mass horrors of World War I, French patriotic nudes fell out of fashion. They turned to other myths: the Oriental vase, carpet, veil, and hookah; or an intimate chair, a garter, and a hat; an open book or two on the couch; or simply a string of pearls—the same pearls that were to reappear in quantity in the silent movies of the early twenties. In such photographs any artistic censorship of head or limb was rightfully scorned; the whole woman had to be there, and yet the effect is odd, for the magnificent torsos are capped by coy and childish faces. But even among this flood of commercial studio work, one discovers an occasional piece that is not just a beautiful and crafty print but in addition has a certain sullen presence—the darker, fiercer, angrier side of sex.

By the thirties, in France, and in Paris particularly, nudity in life and in art had become an assertion of revolt. The Surrealist creed, that elaborate flatulence aimed at the face of authority, emphasized the erotic as proof that the unconscious was anti-bourgeois. Henri Cartier-Bresson made some astonishing nudes. They were consistent with his obsession with the music of human movement, frozen into a silver print. His nudes were of two kinds: the acid group portraits of prostitutes met in his travels through Mexico and Spain; and the series of more intimate and lyric nudes, his friends quite certainly, half submerged in glittering water. In these nudes, he is very close and very cool. He practices the intimacy of the sympathetic surgeon.

One senses, in all his work, whether brilliant or merely good, the entanglements of the world. The naked body is not isolated, as with Man Ray, who treated the nude body as an ideogram of desire. He embellished it with lines of shadow, with false tattoos or painted masks; it was a kind of affectionate wit.

The nudes done by two other exiles to Paris during the same years of world crisis were again quite different. Kertész and Brassaï—they were Hungarians and friends—had risen out of a Central European culture, one that was bored with its own clever provinciality. Faced with the alternatives of the two supremely egotistic civilizations of Berlin and Paris, artists generally chose the latter. Brassaï is the clear-headed, objective, amused observer. He preferred the cabarets and brothels of a nocturnal Paris, subjects that numbered probably a thousandth of its huge population of housewives, workmen, clerks, and students. Although his nudes seem as quick and candid as a momentary glance, this is an illusion. They are carefully watched; the moment is sensed, and lit by magnesium flash, not by accidental light.

André Kertész twisted and doubled his nudes by photographing via mirrors; they look like funhouse ellipsoids and multiplications. He insisted that, no matter what others might say, these nudes *"were just wonderful fun."* How shocking, though, to see a normal middle-aged face with a pleasant smile and fashionable close-cut hair rising out of an optically dwarfish body; these are wonders, like the creatures with several heads that pre-Columbian Europe thought must inhabit the islands at the thin edge of the world. All these monsters of Kertész are not in the least malevolent. As he says, *"I am sentimental; in everything I photograph, there is the human touch."*

Martin Munkacsi and László Moholy-Nagy are two more Hungarian expatriates from the homely provinces, one of whom chose Paris, the second, Berlin. Both came to the United States eventually, but neither man ever lost a certain Austro-Hungarian wit, which they share with Brassaï and Kertész. Their photographs are illuminated with an amusement about human behavior, and a kindly cynicism toward sex, and therefore about nudity. Their lenses continually smile. But a few hundred miles east, there was a Czech intellectual life, centered on Prague, that though it looked toward Paris was plainly attracted by German eroto-romanticism. František Drtikol, in fact, learned his craft in Munich; and never felt so strongly threatened nor repelled by the Nazis that he ever considered exile. His nudes are not photographed outdoors, in the probing, pitiless sun; they are studio nudes, endowed with old fashioned gestures, with drapes, poles, platforms—an East European theater of the naked that has a charming cynicism of its own.

NOWHERE in the world was the old twin deception—that the nude was inherently evil, and that the nude was inherently good—more exaggerated than in the United States. America, with its exuberance of landscape, with its vast transplantation of peoples, the greatest in the history of the world, was fertile with plans for the final improvement of mankind. The very earliest illustrations of voyages to America showed the inhabitants of this new paradise as naturally naked. And we all remember the funny worship of what they conceived to be the Indian way of life, by young middle-class students of the 1960s, complete with headbands and mushrooms; but these were a mere repetition of an ancient syllogism: that nude was natural, that nature was good, and therefore that nude was good. Here is Walt Whitman's view of nudity as the road to health: He would strip himself in the open air and brush his skin till his body *"turn'd scarlet,";* then soak his feet in black mud, and rinse himself in *"crystal running waters."* He concluded:

> *Nature was naked and I was also. . . . Is not nakedness then indecent? No, not inherently. It is your thought, your sophistication, your fear, your respectability, that is indecent. There come moods when these clothes of ours are not only too irksome to wear, but are themselves indecent. Perhaps indeed he or she to whom the free exhilarating extasy of nakedness in Nature has never been eligible (and how many thousands there are!) has not really known what purity is—nor what faith or art or health really is.*

This view was not popular in American literature. One searches without reward in the fine pages of *The Scarlet Letter* (1850) for any particulars of the relationship between Hester Prynne and her clergyman lover. Hawthorne describes a passion composed entirely of consequences. The heroine is disrobed only in the imagination of another woman:

191

"It were well" muttered the most iron-visaged of the old dames, *"if we stripped Madame Hester's rich gown off her dainty shoulders; and as for the red letter, which she hath stitched so curiously, I'll bestow a rag of mine own rheumatic flannel, to make a fitter one!"*

Yet Hawthorne is well aware of the reasons for his circumspection:

> *. . . the generation next to the early immigrants, wore the blackest shade of Puritanism, and so darkened the national visage with it, that all the subsequent years have not sufficed to clear it up. We have yet to learn again of the forgotten art of gaiety.*

In the far more devious Melville, nudity appears in fantastic costume, elaborated into a gigantic metaphor—*The Tartarus of Maids*:

> *. . . lies not far from Woedolor Mountain in New England. Turning to the East, right out from among bright farms and sunny meadows, nodding in early June with odorous grasses, you enter ascendingly among bleak hills. These gradually close in upon a dusky pass. . . .From the steepness of the walls here, their strangely ebon hue, and the sudden contraction of the gorge, this particular point is called the Black Notch. The ravine now expandingly descends into a great, purple, hopper-shaped hollow, far sunk among many Plutonian, shaggy-wooded mountains. By the country people this hollow is called the Devil's Dungeon. Sounds of torrents fall on all sides upon the ear. These rapid waters unite at last in one turbid brick-colored stream, boiling through a flume among enormous boulders. They call this strange-colored torrent Blood River.*

The *"I"* goes up this sensuous road with horse and buggy, ostensibly to visit a paper factory whose workers are all young women, and where he's given a guide called *"Cupid."*

As New York University professor Jay Leyda points out in his preface to *Melville's Shorter Works*:

> *Melville gives one the impression of seeing how close he can dance to the edge of 19th century sanctities without being caught. In this story the*

very audacity of the physiological symbolism was the author's best protection against discovery; the keenest of contemporary readers (with the possibly sole exception of his friend, Dr. Augustus Kinsley Gardner, the gynecologist) would not have dared admit to himself that anyone had been so bold in Harper's pages. . . .

Yet early American painting, of both the male and female, never needed such elaborate stratagems. Nudes were made as early as the mid-eighteenth century, but of course they were justified as they were in Europe. The heathen gods and goddesses in the paintings of John Singleton Copley and Benjamin West were nude because they were specimens of the ideal; and therefore, contrary to Greek mythology, pure. But the funniest and most astonishing act of such absentminded hypocrisy was the enormous American popularity of Hiram Powers' famous 1843 sculpture. Here the young nude wears chains from wrist to wrist; they hide nothing, for links are transparent; and though the statue, hewed of the whitest possible stone, with ideal Anglo features, was baptized *The Greek Slave*, it was explained as no more than a marble proclamation against American slavery. It is only to our sadder and wiser eyes that it appears to be a mild bit of sado-masochism.

But there were few or no camera images of the unclothed body. A small number of early erotic daguerreotypes, some of them in stereo, can be found in American collections, but it's likely they were brought in from France, or even more likely from Germany, where there was a steady and traditional market for what was then, as it still is, regarded as obscene. It appears that there were no serious American photographic studies of the nude until at least 1876. These were the work of Thomas Eakins, who, after studying in Paris, had come back to Philadelphia in 1870. Nude models were common in French schools and not all that exceptional in America, either. In December, 1866, Eakins' friend Charles Fussell wrote him a long, comic letter, prefaced by a remarkably good ink drawing of a life-class, where both men and women students were working from a nude model akimbo on a raised couch.

For his 1883 painting *The Swimming Hole*, not only did Eakins make oil sketches and a wax model of the diver plunging, but he also made a fairly large number of photographs of these young boys (plus a man) in the nude. The painting had been commissioned by a director of the Pennsylvania Academy, but he rejected it because the nudes were not symbolic, but particular; which was true enough, because the nudes were Eakins' friends and pupils, and the adult in the water is the painter himself. The photographs are none of them precisely like the painting. They are studies, raw material for the painting, and yet something more: the essential spirit of photography had saturated Eakins' work forever. Even his bronze reliefs, so saccharine in subject, contradict themselves by the special detail of bone and muscle under the skin. Eakins had written from Paris, in 1868:

> When a man paints a naked woman he gives her less than poor Nature did. I can conceive of few circumstances wherein I would have to paint a woman naked, but if I did I would not mutilate her for double the money. She is the most beautiful thing there is—except a naked man, but I never yet saw a study of one exhibited. It would be a godsend to see a fine man painted in a studio with bare walls, alongside of the smiling, smirking goddesses. . . . I hate affectation.

In 1882, a lady student wrote to Eakins' employer, the president of the Pennsylvania Academy, complaining that nude models in the classroom were the prelude to immorality—because the room was obliged to be heated. Characteristically, Eakins defied this complaint by removing the loin cloth from a male model. He was severely reprimanded, and resigned.

Strangely immune to the puritan temper of American public life was the English immigrant Eadweard Muybridge. His work, up to 1872, had been a series of decent but unexceptional landscapes, often double printed with fluffy clouds. His first studies of motion were commissioned by the railroad millionaire and governor of California, Leland Stanford. By 1877, the first dramatically satisfactory results were obtained: photographs of naked men, women, children, and animals, in fractionally divided curves of motion; sci-

ence was the pretext for beauty. These photographs, published in a huge volume in 1882, set off minor volcanoes in the graphic arts. Muybridge was summoned to lecture in England, France, and Germany.

The realist Eakins had been in correspondence with Muybridge from 1879 onward, and had admired his work immensely. In 1883, backed by an innovative provost at the University of Pennsylvania, Muybridge was invited to work there, and produce a new series in consultation with Eakins. Considering the immense weight of Christian American public opinion against photography of the nude, who were the brave models for his studies? The animals came, perhaps willingly, from the Philadelphia Zoo. The men were largely connected with University athletics, including instructors and students; with one exception—Muybridge himself. The women were either professional models normally used by Eakins in the studio, or "matrons" from high Philadelphia society, or, in one case, a daring young lady who was a dancer in a Philadelphia theater. Muybridge's own description is curiously meticulous:

> The female models were chosen from all classes of society. Number 1, is a widow, aged 35, somewhat slender and above the medium height; 3 is married, and heavily built; 4 to 13 inclusive, 15 and 19, are unmarried, of ages varying from 17 to 24; of these, 11 is slender; the others of medium height and build; 14, 16, and 93, are married; 20, is unmarried, and weighs 340 pounds.

B Y the 1890s, fairly large numbers of upper middle-class young American men and women, particularly those with artistic ambitions, went to Europe to study. Whereas in the early part of the nineteenth century, such (and far fewer) students generally went to England, now they went to France; or, if they had technical ambitions, to Germany. Alfred Stieglitz, heir to a modestly rich inheritance, was one of those students. The American photographer Edward Steichen became his friend and partner, and in fact guided the more ebullient Stieglitz whose artistic horizon was dominated in those early days by the fatty inventions of "German-Roman" painters like the famous Arnold

Böcklin. Böcklin's rosy nudes, sometimes with great fishy tails, swam in the warm tides of his pigment as if reveling in a great, soft, Swiss featherbed.

This Middle European eroticism had its counterpart in French painting (e.g., Bougereau), and appeared in England in the luscious, melancholy nudes and semi-nudes of the pre-Raphaelite painters; in America, this particular attitude toward the human body was to be found in the photographs reproduced in *Camera Work*. The latter was a beautifully printed magazine founded by Stieglitz, which carried, between 1903 and 1917, the work of a whole school of American photography.

The Photo-Secession (named after a German movement in painting called Secession) was an effort to make photography an art and not merely a craft. In spite of the continued puritanism of American life, to photograph the nude had now become richly possible; the invention of the dry plate allowed an easy intervention in the process of printing from the negative. Pigments might be introduced into the bichromate gelatin, and brushwork was common; all this in addition to the practice of defocusing, and to the use of special lenses. In turn, this deliberate softening of the image allowed the photographer to move the real nude toward the ideal, which was less troubling and less censorable.

Much the same thing, and by the same means, was being done in England. For in both countries the realistic, sharply focused nude was still unacceptable for public display. Both André Kertész and Edward Weston complained, as late as 1946, that pubic hair was still censorable. And the male body was even more rare. Of the nearly five hundred photographs reproduced in *Camera Work*, by marvelous gravure on heavy Japanese paper, four were male, and some thirty were female nudes; a number of these were done by women. Those by the Californian Ann Brigman (e.g., herself nude as the dryad of a Monterey cypress) were unctuous beyond belief. But those of the New York City portraitist Alice Boughton had a woman's perception of a woman's body—its softness, its vulnerability. The Bostonian F. Holland Day, whose self-worship was modestly confined to posing himself as Christ on the cross, made several fine photographs of the male nude, all in the first decade of the twentieth century. Steichen, too, made a number of famous studies that (as Shaw remarked) literally turned their back to the scrutiny of American censorship.

The nudes of his contemporary Frank Eugene, though altered, like Steichen's, by strokes of the brush, nevertheless retained a certain quiet sincerity. A. L. Coburn, another member of this movement, did a very fine *Mother and Child* (1909). Also in the pages of *Camera Work* (July 1909, Vol. 27:39), there was an extensive experimental series of portraits done by the team of Clarence White and Alfred Stieglitz. But far better are the nudes done by White alone. They convey the lyric joy of the human body, as part of, and not separate from, the reality of the world.

The nudes done by Stieglitz alone are, like the artist himself, original because caught halfway between two strong currents of late-nineteenth- and early twentieth-century photography. His faith in the contemporary fashion of soft-focus printing was never wholehearted; yet he did not, like the younger, fiercer, more intellectual and doctrinaire Strand, focus down to real optical sharpness. Stieglitz was less interested in the truth of the human body than in the truth of his own emotion. His immense series on his wife Georgia O'Keeffe included some scores of nudes; he saw her very closely and very keenly, but tempered what he knew with what he felt. The emotion of sexual love floods these warm prints; one realizes then that sharp/soft is not really an either/or in photographic beauty; that there are infinite gradations in between; and that, as in Julia Cameron's soft prints, one can be marvelously real; or, as in the work of commercial photographers for *Playboy* and its cheap competitors, sharp and false at the same time.

The nude in every art is confused, as it must and should be, with personal emotion. Two contemporaries, Imogen Cunningham and Edward Weston—and there was mutual admiration between them—are neat examples of this complexity. Edward Weston's nudes, from the earliest (said to be of Ann Brigman herself) to the last wonderful series of his second wife, Charis Wilson, exhibit a conflict consistent with the course of his life. Brought up in a middle-class midwestern American family, he was admitted, by the force of his

own art, into a Los Angeles branch of bohemia—intelligent, argumentative, adventurous and not especially gifted, they were nevertheless his close friends; Weston's earliest nudes date from this association. In most but not all of the hundreds of nudes he made in his life, he eliminated the personal by omitting the face of the model. Was this the false tradition of Greek statuary, amputated by time and burial? Or was it simply to preserve the anonymity of the naked? In any case, this abstract arrangement, this projective geometry of breast, torso, shoulder, and thigh, did certainly solve a good many compositional problems; the face—which we all keep naked—can, when all the rest is nude, make a powerful disturbance. A smaller proportion of Weston's nudes did allow a whole person into view. These photographs have a strongly personal quality; and these were generally of women whom he deeply loved.

Imogen Cunningham, that sibyl of American photography, also did nudes of these two separate kinds: some whole and personal and affectionate—portraits almost; and the others simply parts and arrangements of naked human curves. She herself had a back-country acidity of mind: *"I like people and I dislike them. I always laugh at them. They're such a bunch of nuts really, some nuttier than others."* But these nude still lifes have a special warmth and tactility; they are never merely formal. And they reflect a new, early-century kind of American sexuality, long hidden, but now being expressed even in literature—which in America has always been far more cowardly than the graphic arts.

Sherwood Anderson, writing in the last year of World War I, brought the lonely human body out into the light of the printed page:

Alice went upstairs to her room and undressed in the darkness. For a moment she stood by the window hearing the rain beat against the glass and then a strange desire took possession of her. Without stopping to think of what she intended to do, she ran downstairs through the dark house and out into the rain. As she stood on the little grass plot before the house and felt the cold rain on her body a mad desire to run naked through the streets took possession of her.

Photography had been frank about the human body at least a decade earlier, in work done by a craftsman, not a formal artist. The New Orleans commercial photographer E. J. Bellocq made a living taking glass plates of cargo vessels and warehouses; such cameramen were common in every port, for businessmen have their vanities, too. Bellocq had a congenitally misshapen head, and was, possibly therefore, a good customer of a certain brothel. His photographs of these women, nude or almost nude, are remarkable from every point of view. They were, in my opinion, meant to be used as advertisements; in fact, many brothels had photographic albums for customers to study before choosing. But Bellocq, like so many other artists for thousands of years, did what he was commissioned to do—and at the same time managed to do something more. His photos reveal not only the woman's body and face but her choice of clothing, decoration, a paper flower or an ornate stocking—they are studies of character. They are tender and yet artistically ruthless portraits of these women as particular and irreplaceable people; and they are at the same time beautifully and simply composed.

Again, these photographs were not seen for a couple of generations. By this time, American literature had given birth to its illegitimate child, Henry Miller, and in *Tropic of Cancer* (published in Paris in 1931 and immediately banned in the United States), he certainly broke all the sexual fences of American culture. Yet, in spite of the remarkably infrequent but energetic screwing that goes on across its pages, there is still no real description of a naked woman nor of a naked man. The really ecstatic passages have to do with a kind of cosmic longing; the sex is censored, one might say, by confining it to the genitalia.

WORDS, though, are perhaps the weakest medium for the truths of nakedness; the graphic arts, painting and drawing, are closer to the mark. And it may be that the body, in all its complexity, in its subtle alloy of character, experience, and physical inheritance, is most easily, if still infrequently, the great dominion of the photograph.

Remember that the photographic image, even

when by intention the most mechanical, is almost always dyed with the beautiful, minute, irrational gradations of nature. Thus, one breast is lower than another; the torso has the creases of a long accustomed posture; the look of a moment is forever preserved in the alphabet of the eyes, the lips, the hands; and a fine silk of shadow follows the vagaries of light over the curving back. There are rich nuances, too complex to be verbal, of a bent or a crossed knee, of the angle held between the ankles, as abstract as if it were ballet; or the emotional sign of a stomach curved and lax, or flat and restrained, according to the canons of that decade; or the sign of the pubic hair, as directional as an arrow; or the simple weight and balance of the body. Only the nude can render these delicacies of the human animal.

Finally, any collection of photographed nudes, graced thus with the beauty of honest observation, and made dense by the attachments of our own private history as well, is bound to be erotic. But eroticism is not, or should not be, a narrow state of mind; it ought to imply, even in photographs of the tender acrobatics of love, a great deal more. Cartier-Bresson's photograph of two women on a cot in Mexico (*Plate* 57) has, in its hungry intensity, not only a reference to Gustave Courbet's famous *Two Friends*, but a more universal insight into the blind, deaf concentration of physical sex; and this in spite of the fact that the show was put on especially for him to photograph.

One should redefine eroticism in respect to the nude in art of any sort, and of photography in particular, as not only the quick fantasy of sex, but the more subtle aura of tenderness, of that mixture of mental touch, aroma, voice, and the slow wanderings of the eyesight; and as something larger and more indefinable still—the sense of common acquaintance, beyond clothes and manners, with all other members of our species, living and dead.

BEN MADDOW

196

LIST OF PLATES

1. FR. J. MOULIN. French. *Couple Embracing.* Circa 1855. Daguerreotype. Collection of GERARD LEVY, Paris.

2. ANONYMOUS. French. *Untitled.* Circa 1850. Daguerreotype. Collection of Bokelberg, Hamburg, Germany.

3. ANONYMOUS. French. *Untitled.* Circa 1855. Daguerreotype. Rubel Collection, courtesy of Thackrey & Robertson, San Francisco.

4. ANONYMOUS. French. *Reclining Nude.* Circa 1855. Stereoscopic daguerreotype. Collection of GERARD LEVY, Paris.

5. ANONYMOUS. French. *Standing Nude with Violin.* Circa 1850. Daguerreotype. Collection of GERARD LEVY, Paris.

6. ANONYMOUS. French. *Nude on Striped Bedspread.* Circa 1855. Hand-colored stereoscopic daguerreotype. Collection of GERARD LEVY, Paris.

7. ANONYMOUS. French. *Removing the Garter.* Circa 1855. Hand-colored stereoscopic daguerreotype. Collection of GERARD LEVY, Paris.

8. ANONYMOUS. French. *Standing Male Nude.* Circa 1855. Stereoscopic daguerreotype. Collection of GERARD LEVY, Paris.

9. ANONYMOUS. French. *Nude with Column.* Circa 1855. Stereoscopic daguerreotype. Collection of GERARD LEVY, Paris.

10. ANONYMOUS. French. *Untitled.* Circa 1850. Hand-colored stereoscopic daguerreotype. Collection of Samuel Wagstaff, New York.

11. ANONYMOUS. French. *Untitled.* Circa 1855. Hand-colored stereoscopic daguerreotype. Collection of TEXBRAUN, Paris.

12. BRAQUEHAIS. French. *Nude.* Circa 1856. Albumen print. Collection of Samuel Wagstaff, New York.

13. EUGÈNE DURIEU. French. *Nude* (from album belonging to Delacroix). Circa 1853. Albumen print. Collection of Bibliothèque Nationale, Paris.

14. BRAQUEHAIS. *Woman with Basket.* Circa 1854. Albumen print. Courtesy of Daniel Wolf Gallery, New York.

15. ROGER FENTON. British (1819-1869). *Study of a Partially Draped Young Lady.* Circa 1855. Collection of Victoria and Albert Museum, London.

16. ANONYMOUS. French. *Untitled* (nude study made for the French army). Circa 1880. Albumen print. Collection of J. P. Bougeron, Paris.

17. NADAR (Gaspard Félix Tournachon). French (1820-1910). *Nude.* Circa 1860. Albumen print. Collection of GERARD LEVY, Paris.

18. ANONYMOUS. French. *Nude.* Circa 1855. Albumen print. Collection of Samuel Wagstaff, New York.

19. ANONYMOUS. French. *Model, Paris.* Circa 1900. Albumen print. Collection of Howard Ricketts Limited, London.

20. ANONYMOUS. American. *Untitled* (wounded Civil War veteran). n.d. Albumen print. Collection of Arnold H. Crane, Chicago.

21. NADAR. *Hermaphrodite.* Circa 1860. Albumen print. Collection of TEXBRAUN, Paris.

22. BARON WILHELM VON GLOEDEN. German (1856-1931). *Untitled.* Circa 1890. Albumen print. Courtesy of Agathe Gaillard Gallery, Paris.

23. BARON WILHELM VON GLOEDEN. *Untitled.* Circa 1890. Albumen print. Courtesy of Agathe Gaillard Gallery, Paris.

24. EADWEARD MUYBRIDGE. American (born England, 1830-1904). Plate 369 from *Animal Locomotion.* 1887. Albumen print. Collection of the International Museum of Photography at George Eastman House, Rochester, New York.

25. EADWEARD MUYBRIDGE. Plate 73 from *Animal Locomotion.* 1887. Albumen print. Collection of Diana M. Edkins, New York.

26. THOMAS EAKINS. American (1844-1916). *Male Nudes Wrestling.* Circa 1883. Albumen print. Courtesy of Olympia Galleries, Ltd. Philadelphia, Pennsylvania and Atlanta, Georgia.

27. THOMAS EAKINS. *Male Nudes in Standing Tug-of-War.* Circa 1883. Albumen print. Courtesy of Olympia Galleries, Ltd., Philadelphia, Pennsylvania and Atlanta, Georgia.

28. THOMAS EAKINS. *Male Nudes at a Swimming Hole.* Circa 1883. Albumen print. Courtesy of Olympia Galleries, Ltd., Philadelphia, Pennsylvania and Atlanta, Georgia.

29. THOMAS EAKINS. *Studio Nudes Posing at the Pennsylvania Academy of the Fine Arts.* Circa 1883. Albumen print. Courtesy of Olympia Galleries Ltd., Philadelphia, Pennsylvania and Atlanta, Georgia.

30. THOMAS EAKINS. *Studio Nudes Posing at the Pennsylvania Academy of the Fine Arts.* Circa 1883. Albumen print. Courtesy of Olympia Galleries Ltd., Philadelphia, Pennsylvania and Atlanta, Georgia.

31. EDGAR DEGAS (attributed to). French (1834-1917). *Nude.* Circa 1895. Bromide print. Collection of Samuel Wagstaff, New York.

32. EDGAR DEGAS (attributed to). *Seated Nude.* Circa 1895. Bromide print. Collection of Samuel Wagstaff, New York.

33. CLARENCE H. WHITE (American, 1871-1925) and ALFRED STIEGLITZ (American, 1864-1946). *Nude.* 1907. Platinum print. Collection of the Museum of Modern Art, New York. Gift of Mr. and Mrs. Clarence H. White, Jr.

34. CLARENCE H. WHITE. *Nude with Baby.* 1912. Gum print. Collection of the Library of Congress, Washington, D.C.; Prints and Photographs Division.

35. F. HOLLAND DAY. American (1864-1933). *Untitled* (nude youth in front of cave). n.d. Platinum print. Collection of the Library of Congress, Washington, D.C.; Prints and Photographs Division.

36. EDWARD STEICHEN. American (born Luxembourg, 1879-1973). *The Model and the Mask.* 1906. Plate VIII from *Camera Work*, Steichen Supplement. Gravure print. Collection of the International Museum of Photography at George Eastman House, Rochester, New York.

37. CLARENCE H. WHITE and ALFRED STIEGLITZ. *Nude* (back view with scull). Circa 1900. Platinum print. Collection of the Museum of Modern Art, New York. Gift of Clarence H. White, Jr.

38. FRANK EUGENE. American (1865-1936). *Male Nude Portrait* (brother Freddy). 1913. Platinum print. Courtesy of David Mancini Gallery, Philadelphia, Pennsylvania.

39. CLARENCE H. WHITE and ALFRED STIEGLITZ. *Miss Thompson.* 1907. Waxed platinum print. The Metropolitan Museum of Art, New York, The Alfred Stieglitz Collection.

40. EDWARD WESTON. American (1886-1958). *Margrethe Mather on Horsehair Sofa.* Circa 1923. Platinum print. Courtesy of Daniel Wolf Gallery, New York.

41. IMOGEN CUNNINGHAM. American (1883-1976). *Roi on the Dipsea Trail 4.* 1918. Silver print. Courtesy of The Imogen Cunningham Trust, Berkeley, California.

42. IMOGEN CUNNINGHAM. *Rondal and Padraic in the Sierras.* 1924. Silver print. Courtesy of The Imogen Cunningham Trust, Berkeley, California.

43. IMOGEN CUNNINGHAM. *Twins with Mirror.* 1923. Silver print. Courtesy of The Imogen Cunningham Trust, Berkeley, California.

44. IMOGEN CUNNINGHAM. *Two Sisters.* 1928. Silver print. Courtesy of The Imogen Cunningham Trust, Berkeley, California.

45. DOROTHEA LANGE. American (1895-1965). *Torso, San Francisco.* 1923. Silver print. The Oakland Museum, Oakland, California, The Dorothea Lange Collection.

46. MARGRETHE MATHER. American (1885-1952). *Semi-nude* (man in kimono). Circa 1923. Silver print. Collection of the Center for Creative Photography, University of Arizona, Tucson.

47. EDWARD WESTON. *Neil.* 1922. Silver print. Courtesy of The Edward Weston Estate.

48. EDWARD WESTON. *Neil.* 1922. Silver print. Courtesy of The Edward Weston Estate.

49. ANONYMOUS. American. *Untitled.* Circa 1910. Modern silver print made from the original glass plate. Collection of Robert Mapplethorpe, New York.

50. ATGET (Jean-Eugène-Auguste). French (1857-1927). *Femme.* Circa 1910. Silver print. Collection of the International Museum of Photography at George Eastman House, Rochester, New York.

51. E. J. BELLOCQ. American (1873-1949). *Untitled.* Circa 1912. Modern silver print made by Lee Friedlander from the original glass plate. Courtesy of Lee Friedlander.

52. E. J. BELLOCQ. *Untitled.* Circa 1912. Modern silver print made by Lee Friedlander from the original glass plate. Courtesy of Lee Friedlander.

53. BARON ADOLPH DE MEYER. German (1868-1946). *Dance Study.* Circa 1912. Gelatine silver print. The Metropolitan Museum of Art, New York, The Alfred Stieglitz Collection, 1949.

54. BRASSAÏ (Gyula Halász). Romanian (born 1899). *La Presentat Chez Su Ly,* Paris. Circa 1932. Silver print. Courtesy of the photographer.

55. BRASSAÏ. *Une Fille de Joie,* Paris. Circa 1932. Silver print. Courtesy of the photographer.

56. HENRI CARTIER-BRESSON. French (born 1908). *Untitled,* Italy. 1933. Silver print. Courtesy of the photographer.

57. HENRI CARTIER-BRESSON. *Untitled,* Mexico. 1934. Silver print. Courtesy of the photographer.

58. MARTIN MUNKACSI. Hungarian (1896-1963). *Nude on Bed.* Circa 1929. Silver print. Courtesy of Joan Munkacsi.

59. FRANTIŠEK DRTIKOL. Czechoslovakian (1878-1961). *Nude.* 1929. From *Les Nus de Drtikol,* published by Librairie des Arts Decoratifs, Paris, 1929. Gravure print. Collection of the International Museum of Photography at George Eastman House, Rochester, New York.

60. PAUL OUTERBRIDGE, JR. American (1896-1958). *Young Girl Nude with Shoes On.* Circa 1924. Platinum print. Courtesy of Robert Miller Gallery, Inc., New York.

61. ANONYMOUS. French. *Model, Paris.* Circa 1895. Collection of Howard Ricketts Limited, London.

62. FRANTIŠEK DRTIKOL. *Untitled.* n.d. Courtesy of Stephen White Gallery, Los Angeles.

63. PAUL OUTERBRIDGE, JR. *Nude.* 1928. Platinum print. Courtesy of G. Ray Hawkins Gallery, Los Angeles.

64. PAUL OUTERBRIDGE, JR. *Untitled.* 1938. Carbro color print. Courtesy of G. Ray Hawkins Gallery, Los Angeles.

65. HANS BELLMER. French, born in Germany (1902-1975). *Untitled.* n.d. From his book *Le Jeu de la Poupée,* 1949. Hand-colored silver print. Private collection.

66. PAUL OUTERBRIDGE, JR. *Nude with Spiked Gloves.* n.d. Color carbro print. Courtesy of Robert Miller Gallery, Inc., New York.

67. MAN RAY. American (1890-1976). *Untitled.* n.d. Silver print. Private collection.

68. MAN RAY. *Reclining Nude.* 1929. Solarized silver print. Collection of Arnold H. Crane, Chicago.

69. MAN RAY. *Meret Oppenheim,* Paris. 1935. Silver print. Courtesy of the estate of Man Ray.

70. MAN RAY. *Reclining Nude.* 1920. Silver print. Collection of Arnold H. Crane, Chicago.

71. LÁSZLÓ MOHOLY-NAGY. Hungarian (1895-1946). *Two Nudes* (positive image). Circa 1925. Silver print. Collection of the International Museum of Photography at George Eastman House, Rochester, New York.

72. LÁSZLÓ MOHOLY-NAGY. *Two Nudes* (negative image). Circa 1925. Silver print. Collection of the International Museum of Photography at George Eastman House, Rochester, New York.

73. LÁSZLÓ MOHOLY-NAGY. *Belle Isle.* n.d. Silver print. Collection of The Art Museum, Princeton, New Jersey. David H. McAlpin Fund.

74. DOROTHEA LANGE. *Soquel Creek, California.* 1930. Silver print. The Oakland Museum, Oakland, California, The Dorothea Lange Collection.

75. EDWARD WESTON. *Nude Floating.* 1939. Silver print. Courtesy of The Edward Weston Estate.

76. MARTIN MUNKACSI. *Untitled.* 1935. Silver print. Courtesy of Joan Munkacsi.

77. MARTIN MUNKACSI. *Untitled.* 1935. Silver print. Courtesy of Joan Munkacsi.

78. GEORGE PLATT LYNES. American (1907-1955). *Untitled.* Circa 1930. Silver print. Courtesy of Sonnabend Gallery, New York.

79. GEORGE PLATT LYNES. *Untitled.* Circa 1930. Silver print. Courtesy of Sonnabend Gallery, New York.

80. ROGER PARRY. French (1905-1977). *Nude Study.* Circa 1929. Silver print. Collection of Callaway Editions. Copyright ©1980 by Callaway Editions, Inc.

81. FRANTIŠEK DRTIKOL. *Untitled.* n.d. Silver print. Collection of the International Museum of Photography at George Eastman House, Rochester, New York.

82. FRANCIS BRUGUIÈRE. American (1879-1945). *Solarization.* 1925. Silver print. Collection of the International Museum of Photography at George Eastman House, Rochester, New York.

83. FRANCIS BRUGUIÈRE. *Solarization.* 1925. Silver print. Collection of the International Museum of Photography at George Eastman House, Rochester, New York.

84. FRANCIS BRUGUIÈRE. *Untitled.* n.d. Silver print. Collection of the International Museum of Photography at George Eastman House, Rochester, New York.

85. ANDRÉ KERTÉSZ. Hungarian (born 1894). *Distortion No. 91*. 1933. Silver print. Courtesy of the photographer.

86. BILL BRANDT. British (born 1904). *Nude*. 1956. Silver print. Copyright © by Bill Brandt Rapho/Photo Researchers.

87. ANDRÉ KERTÉSZ. *Distortion No. 20*. 1933. Silver print. Courtesy of the photographer.

88. ANDRÉ KERTÉSZ. *Nude*. 1939. Silver print. Courtesy of the photographer.

89. BILL BRANDT. *Nude*. n.d. Silver print. Copyright © by Bill Brandt Rapho/Photo Researchers.

90. EDWARD WESTON. *Nude*. 1934. Silver print. Courtesy of The Edward Weston Estate.

91. EDWARD WESTON. *Nude*. 1933. Silver print. Courtesy of The Edward Weston Estate.

92. EDWARD WESTON. *Nude*. 1928. Silver print. Courtesy of The Edward Weston Estate.

93. EDWARD WESTON. *Nude*. n.d. Silver print. Courtesy of The Edward Weston Estate.

94. EDWARD WESTON. *Charis on the Dunes*. 1936. Silver print. Courtesy of The Edward Weston Estate.

95. MANUEL ALVAREZ BRAVO. Mexican (born 1902). *La Desvendada*. 1938. Silver print. Courtesy of the photographer.

96. MANUEL ALVAREZ BRAVO. *Tentaciones en Casa de Antonio*. 1970. Silver print. Courtesy of the photographer.

97. MANUEL ALVAREZ BRAVO. *La Negra*. 1959. Silver print. Courtesy of the photographer.

98. PAUL STRAND. American (1890-1976). *Torso, Taos, New Mexico*. 1930. Silver print. Copyright © 1976 by the Estate of Paul Strand and Hazel Strand as reproduced in *Portfolio I: On My Doorstep*.

99. MINOR WHITE. American (1908-1976). *Male Nude*. 1940. Silver print. Collection of Robert Mapplethorpe, New York.

100. MINOR WHITE. *Nude* from the sequence, *Temptation of St. Anthony*. 1948. Silver print. Courtesy of the Minor White Archive, Princeton University. Copyright © by The Trustees of Princeton University.

101. WALTER CHAPPELL. American (born 1925). *Father and Son, Wingdale, New York*. 1962. Silver print. Courtesy of the photographer.

102. HARRY CALLAHAN. American (born 1912). *Chicago*. 1953. Ektacolor RC print. Courtesy of the photographer.

103. HARRY CALLAHAN. *Eleanor*. 1950. Ektacolor RC print. Courtesy of the photographer.

104. HARRY CALLAHAN. *Eleanor, Chicago*. 1949. Silver print. Courtesy of the photographer.

105. HARRY CALLAHAN. *Eleanor, Chicago*. 1953. Silver print. Courtesy of the photographer.

106. FREDERICK SOMMER. American (born Italy, 1905). *Untitled*. 1965. Silver print. Collection of the Norton Simon Museum of Art at Pasadena, California.

107. FREDERICK SOMMER. *Untitled*. 1961. Silver print. Collection of the Norton Simon Museum of Art at Pasadena, California.

108. BILL BRANDT. *Nude*. 1953. Silver print. Copyright © by Bill Brandt Rapho/Photo Researchers.

109. TODD WALKER. American (born 1917). *Untitled*. 1969. Silver print. Courtesy of the photographer.

110. EMMET GOWIN. American (born 1941). *Edith, Danville, Virginia*. 1972. Silver print. Courtesy of the photographer.

111. EMMET GOWIN. *Edith, Newtown, Pennsylvania*. 1974. Silver print. Courtesy of the photographer.

112. EMMET GOWIN. *Edith, Danville, Virginia.* 1973. Silver print. Courtesy of the photographer.

113. AARON SISKIND. American (born 1903). *Bill Lipkind 4.* 1960. Silver print. Courtesy of Light Gallery, New York.

114. JOEL MEYEROWITZ. American (born 1938). *Vivian.* 1976. Ektacolor RC color print. Courtesy of the photographer.

115. DAVID HOCKNEY. British (born 1937). *Peter Showering, Paris.* July, 1975. From the portfolio: *Twenty Photographic Pictures by David Hockney,* edited by Sonnabend Gallery, New York. Ektacolor RC color print. Courtesy of Sonnabend Gallery, New York.

116. DAVID HOCKNEY. *Peter Washing, Belgrade.* September, 1970. From the portfolio: *Twenty Photographic Pictures by David Hockney,* edited by Sonnabend Gallery, New York. Ektacolor RC color print. Courtesy of Sonnabend Gallery, New York.

117. JOEL MEYEROWITZ. *Cynthia.* 1977. Ektacolor RC color print. Courtesy of the photographer.

118. HENRY WESSEL, JR. American (born 1942). *California.* 1975. Silver print. Courtesy of the photographer.

119. ROBERT MAPPLETHORPE. American (born 1946). *François Wimille, Giorde, France.* 1976. Silver print. Courtesy of the photographer.

120. TOD PAPAGEORGE. American (born 1940). *Rochester, New York.* 1970. Silver print. Courtesy of the photographer.

121. MANUEL ALVAREZ BRAVO. *Título: Sin Título.* 1978. Silver print. Courtesy of the photographer.

122. ROGER MERTIN. American (born 1942). *Casual (?) Heart #1, 2nd Version.* From the series *Plastic Love Dream.* 1969. Silver print. Courtesy of the photographer.

123. ROGER MERTIN. *Untitled.* From the series *Plastic Love Dream.* 1968. Silver print. Collection of Diana M. Edkins, New York.

124. LINDA S. CONNOR. American (born 1944). *Untitled.* 1976. Silver print. Courtesy of the photographer.

125. SHEILA METZNER. American (born 1939). *Bega, Chatham.* 1978. Silver print. Courtesy of Daniel Wolf Gallery, New York.

126. ART SINSABAUGH. American (born 1924). *Mark and Sherry #12.* 1969. Silver print. Courtesy of the Art Sinsabaugh Archive, Indiana University Art Museum, Bloomington, Indiana.

127. RICHARD BENSON. American (born 1943). *Meriden, Connecticut.* 1969. Palladium print. Courtesy of Washburn Gallery, New York.

128. WILLIAM EGGLESTON. American (born 1939). *Greenwood, Mississippi.* Circa 1971. Ektacolor RC color print. Courtesy of the photographer.

129. RICHARD PARE. American (born 1948). *Trans en Provence, August 4, 1979.* Ektacolor RC color print. Courtesy of the photographer.

130. RICHARD PARE. *L.V., Chicago.* 1977. Polaroid SX 70 print. Courtesy of the photographer.

131. RICHARD PARE. *Christmas, Garrison.* 1978. Polaroid SX 70 print. Courtesy of the photographer.

132. ROBERT HEINECKEN. American (born 1931). *Autographic Glove/Lace.* 1974. Hand-colored silver print. Courtesy of the photographer.

133. ROBERT HEINECKEN. *Autographic Glove/Hair.* 1974. Silver print. Courtesy of the photographer.

134. SHEILA METZNER. *Evyan, Woodstock.* 1970. Silver print. Courtesy of Daniel Wolf Gallery, New York.

ACKNOWLEDGMENTS

THE preparation of this book involved many people who gave generously of their time and expertise. Eleanor Caponigro designed the book and supervised printing and production. Her commitment to quality was unflagging. Roger W. Straus, III at Harper & Row made the project a realization and was supportive throughout. Sallie Gouverneur and Joseph Montebello attended cheerfully to the nasty details of getting it done. Jeffrey Paley, Susan Weiley and Marjorie Weinman read and commented on portions of the text. Thanks go to Diana Edkins for sharing her knowledge of the history and her fine critical and aesthetic sense, to Robert Gordon for time shared in ferreting out collections in Paris, and to Richard Pare for his enthusiasm and his thoughts on significant work.

An immense debt is owed to the collectors, curators and librarians who made material available for study and reproduction. David Travis, Curator of Photography, the Art Institute of Chicago; Bruce Bernard, The London *Sunday Times*; Bernard Marbot, Curator, Department of Prints and Photographs, Bibliothèque Nationale, Paris; Bruno Bischofberger, Kusnacht, Switzerland; Werner Bokelberg, Hamburg, West Germany; Jean-Pierre Bougeron, Paris; François Braunschweig, Collection Texbraun, Paris; Jean-Jacques Poulet Allamagny, Caisse Nationale des Monuments Historiques et des Sites, Paris; Paul Cava, Philadelphia; James L. Enyeart, Director, Center for Creative Photography, University of Arizona, Tucson; Stuart Bennett, Christie's South Kensington, Ltd., London; Arnold Crane, Chicago; Danee McFarr, Administrator, The Imogen Cunningham Trust, Berkeley, California; Lee Friedlander; James Alinder, Friends of Photography, Carmel, California; Susan Stromey, Study Center, and Michael Kamins, Print Service, the International Musuem of Photography at George Eastman House, Rochester, New York; G. Ray Hawkins, G. Ray Hawkins Gallery, Los Angeles, California; Michael E. Hoffman, *Aperture*, Millerton, New York; Gerard Levy, Paris; Allen Fern and Gerald Maddox, Department of Prints and Photographs, Library of Congress, Washington, D.C,; Charles Traub, The Light Gallery, New York; David Mancini, Photopia Gallery, Philadelphia, Pennsylvania; Weston J. Naef, Assistant Curator, Department of Prints and Photographs, The Metropolitan Museum of Art, New York; Susan Kismaric, The Museum of Modern Art, New York; Lynne Sheehan, The National Gallery of Art, Washington, D.C.; Nancy Kemper, Norton Simon Museum of Art at Pasadena, California; Therese Heyman, Curator of Prints and Photography, The Oakland Museum, California; Marcuse Pfeifer, Marcuse Pfeifer Gallery, New York; Suzanne Goldstein, Photo Researchers, New York; Peter C. Bunnell, Curator of Photography, The Art Museum, Princeton University; Howard Ricketts Limited, London; Valerie Lloyd, Curator, The Royal Photographic Society of Great Britain, London; Joel Snyder, Chicago; Madame C. Roger, Société Française de Photographie, Paris; Antonio Honnem, Sonnabend Gallery, New York; Bill Eglon Shaw, The Sutcliffe Gallery, Whitby, North Yorkshire, England; Thackrey & Robertson, San Francisco, California; Lucien Treillard for the estate of Man Ray, Paris; Samuel Wagstaff, New York; Paul Walter, New York; Cole Weston, Carmel, California; Courtia Worth, The Witkin Gallery, New York; Clarence White, Jr., Georgetown, Maine; Daniel Wolf, Daniel Wolf Inc., New York.

Most of all, thanks to the photographers who made these images, and to those who lent their work and support to the project.

CONSTANCE SULLIVAN

NUDE: PHOTOGRAPHS 1850-1980

This book has been set in Palatino and Aldus by Mackenzie-Harris Corporation, San Francisco, California,
and was printed by the Acme Printing Company, Inc., Medford, Massachusetts,
and bound by Publishers Bookbinding, Long Island City, New York.
It was designed by Eleanor Morris Caponigro, Santa Fe, New Mexico.